COAL
BRITISH MINING IN ART 1680-1980

An exhibition organised
by the Arts Council of Great Britain
with the National Coal Board
and supported by Barclays Bank

1 October – 6 November 1982
**City Museum & Art Gallery,
Stoke-on-Trent**

13 November – 18 December 1982
Glynn Vivian Art Gallery, Swansea

8 January – 6 February 1983
Science Museum, London

19 February – 20 March 1983
D.L.I Museum & Arts Centre, Durham

26 March – 1 May 1983
Castle Museum, Nottingham

Exhibition Committee:

National Coal Board

David Brandrick, CBE	Secretary of the National Coal Board
Norman Woodhouse	Deputy Director of Public Relations
Ken Harding	Publicity Manager, Public Relations
Michael Munchick	Business Organiser, Coal News
Dr. John Kanefsky	Secretary's Department
Jack Reading	formerly with Coal Industries Social Welfare Organisation

Arts Council of Great Britain

Michael Harrison	Assistant Director for Regional Exhibitions
Michael Regan	Exhibition Organiser
Pat Van Pelt	Art Education Officer
Joan Asquith	Art Publicity Officer
Douglas Gray	Exhibition Selector

Barclays Bank

Michael Wilmore	Group Public Relations

Association of British Mining Equipment Companies
(ABMEC)

Leslie Reid, CBE	Director General

Exhibition selected by Douglas Gray
and organised by Michael Regan,
assisted by Umran Tossoun

Education Liaison: Pat Van Pelt

Exhibition graphics and catalogue design
Peter Nutter/Thumb Design Partnership

Printed by Veenman Wageningen, Drukkerijen,
Holland

SB ISBN 0 7287 0329 7
HB ISBN 0 7287 0333 5

Cover illustration:
British School, *Pithead of Coalmine with Steam
Winding Gear,* c. 1820
Walker Art Gallery, Liverpool. (Cat. No. 32)

CONTENTS

Acknowledgements 4

Forewords by Mr Norman Siddall CBE
and Sir William Rees-Mogg 5

Art and Coal by Douglas Gray 7-42

The Development of the British Coal
Industry by Dr John Kanefsky 43-54

Catalogue 55-91

Chronology 92-93

Artists' index 94

List of Lenders 95

Select Bibliography 96

ACKNOWLEDGEMENTS

The exhibition **Coal: British Mining in Art 1680-1980** has been organised as a collaboration between the National Coal Board and the Arts Council of Great Britain. Many other individuals and organisations have helped us to realise our project.

We are grateful to Barclays Bank for its generous support of the exhibition and to the Association of British Mining Equipment Companies (ABMEC) for its contribution towards the cost of this catalogue.

We thank the many museums and collectors who have so readily lent their pictures and allowed the exhibition to become a remarkably full survey of its theme.

To coincide with the exhibition's tour, local branches of the National Union of Mine Workers have most generously made available a selection of their banners to hang in the host venues.

Finally our thanks go to those whose knowledge and energy have formed the exhibition: Mr Douglas Gray, who has selected and devised the exhibition; Dr John Kanefsky, who has contributed an essay on the history of the industry and provided a great deal of technical information; and Mr Jack Reading whose enthusiasm and advice have been of great encouragement.

Joanna Drew
Director of Art
Arts Council of Great Britain

A list of Arts Council publications,
including all exhibition catalogues in print,
can be obtained from the
Publications Officer,
Arts Council of Great Britain,
105 Piccadilly, London. W1V OAU.

In the preparation of an exhibition like this one, it has been necessary to solicit help from many sources, and I acknowledge with gratitude all kinds of advice and assistance from a number of people. I am particularly grateful to the following:

Jack Reading, who has championed the idea of the exhibition and played an important part in its realisation, George Rees, General Secretary of the National Union of Mine Workers (South Wales) for making possible my visit to Bochum; Dr Angela John, of Thames Polytechnic, for her constant encouragement; Manfred Fronz, and the staff of Bergbau Museum, Bochum, in particular to Dr Rainer Slotta; David de Haan, Ironbridge Gorge Museum, for his generous assistance; the Warden and staff of Graham House, Newcastle for their hospitality and access to the Ashington Group pictures; Bill Cleaver, for his personal interest and help, and to Dr Peter Phillips, for his early encouragement for the project.

Douglas Gray
Exhibition Selector

FOREWORD

Coal has played a vital part in the British economy for more than three centuries and was the foundation of the industrial revolution which made Britain 'the workshop of the world'. Today the coal industry has an assured future, with several hundred years of reserves still available, and will continue to play that central role.

The industry has long held the fascination of writers and artists, and the National Coal Board have been glad to join with the Arts Council of Great Britain in organising the most comprehensive exhibition of mining art ever assembled in Great Britain. The works displayed cover the whole range of the industry's operations from coalface to customer and admirably display the particular character of both coalmines and the men who have worked in them over the years. They chronicle the development of the industry from small beginnings to the highly technological industry of today.

This illustrated catalogue is both a companion to and commentary on the exhibition. I am sure that it will become a definitive guide to the artist's view of this unique industry.

Norman Siddall C B E
Chairman, National Coal Board

From its earliest days the Arts Council has taken a great variety of exhibitions to galleries throughout Great Britain. Recently a number of these exhibitions have speculated upon the nature of art itself and its relationship with the society from which it has emerged.

The exhibition, of which this catalogue provides a full record, allows us to look at art produced over three centuries linked by its common subject of the coal mining industry. The industrial and social revolutions which the pictures reflect are paralleled by the extraordinary changes which have taken place in art. Few exhibitions could bring together the painting of John Constable, the drawing of Henry Moore and the photographically based work of artists such as Bernd and Hilla Becher. Yet, as the aims of the coal industry have remained constant, so have many of the intentions and aspirations of the artists.

We have been delighted to collaborate with the National Coal Board in this exciting venture.

Sir William Rees-Mogg
Chairman, Arts Council of Great Britain

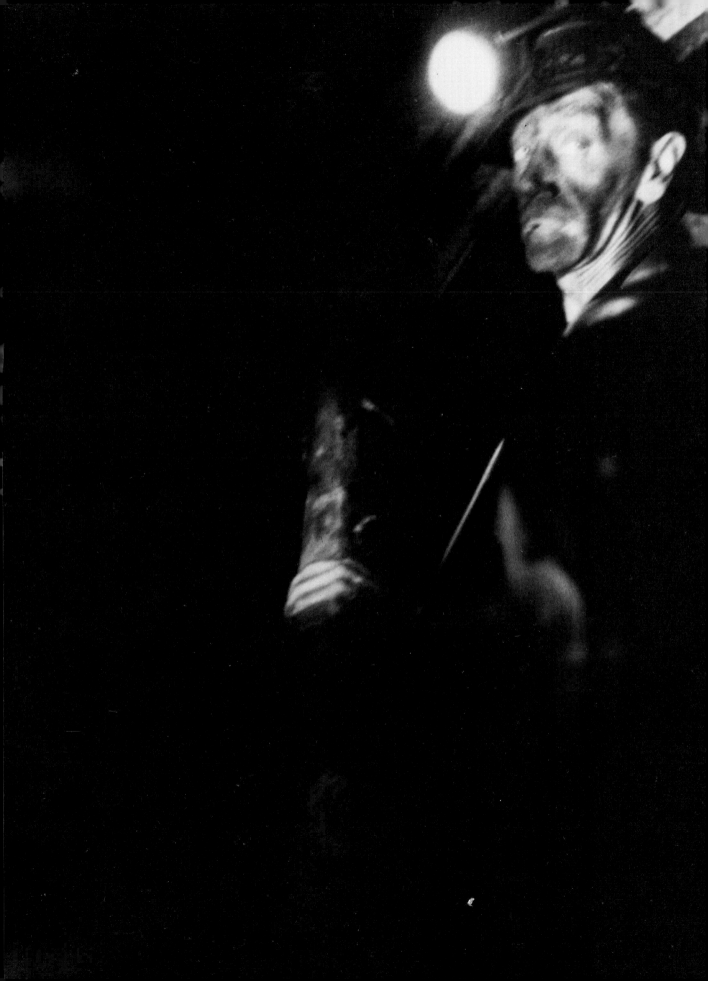

ART AND COAL

Art and Coal - an incongruous and unsympathetic marriage, one would assume. Yet it has been possible to select for this exhibition 150 pictures that depict the full spectrum of coal mining activity in the British Isles during the last 300 years. The range of imagery on display encapsulates the impact of coal as a source of power for technological, economic and social change. It also expresses the artist's graphic vision of that source of power, and his or her personal response to it.
That response offers a rich variety of artistic innovation both in content and manner.

Coal mining has a long and chequered history. In Britain alone, written accounts of its discovery and extraction date back to the Roman occupation. Archaeological evidence establishes its use in at least two places by that time, the now world famous North Eastern coalfield around Newcastle and the less known Forest of Dean straddling the counties of Gloucestershire and Monmouthshire. Pictorially however, the time scale is of a much shorter span. Except for extremely rare examples, of amphora decoration from the 6th Century BC and a sandstone relief from the 3rd Century AD, images of the mining genre are a relatively modern phenomenon. Furthermore, the antique references do not depict coal; their themes are salt and copper, minerals having spiritual or magical associations. Over one thousand years elapsed before mining became the subject matter of fine or applied art again.

It was artists of 16th Century Europe who established themselves as the progenitors of a new and revolutionary view of life. With the publication of *De Re Metallica*, an illustrated treatise on metal mining by Georg Agricola, the graphic exploration of the industry was given a tremendous boost. The drawings which accompanied the text explained in great detail the nature of mining, the technology and processes of refining, the tools and mechanical devices used, and included accurate visual descriptions of the miners themselves. There can be no doubt that this book with its technically excellent draughtsmanship forged the main link connecting those disparate elements, fine art and mining themes. Agricola's systematic investigations were taken up in a host of other works of the period. Recent research has revealed drawings, books, tapestries and church brasses, all of which have references to or whose subject matter is mining. A fantasy landscape from the *Wolfegger Hausbuchs* is as early as 1480, and a superb Gobelin tapestry dates from 1501-4. The British Museum has a drawing of miners at work by Hans Holbein the younger, and the Annaberg Altarpiece painted in 1521 by Hans Hesse for the miners of the Erzgelbirge region of Saxony has four panels detailing

Opposite
Robert Frank
Miner Underground 1951
(Cat. No 158)

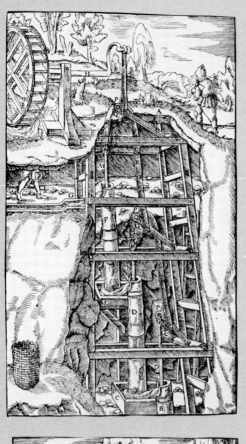

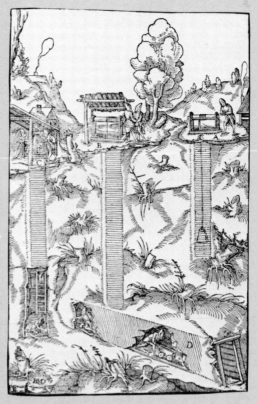

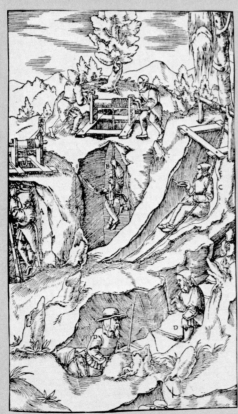

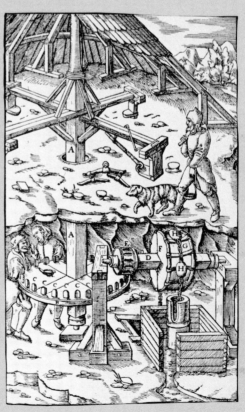

the whole process of ore mining. Its large centre panel has a spiralling pictorial narrative of pit heads, windlasses, miners, mine owners and, finally, an angel with outstretched arms reaching down whilst overlooking the scene.

St Barbara and St Daniel appear very early as the guardian angels of miners both as church statuary and painted portraits. The

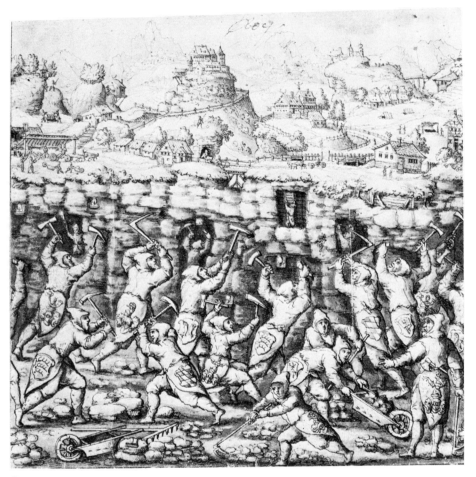

a.

Opposite
Pages from *De Re Metallica*
16th Century

a) Fantasy Landscape from *Wolfegger Hausbuchs* c.1480

b) Miner's Brass, Newland Parish Church, 14th Century

involvement of religious orders in the development of the coal industry is recorded in the Boldon book of Bishop Pudsey in 1180. Land at Escomb near Bishop Auckland, also in the diocese of Durham Cathedral, was worked to provide coal for the 'cart' smith at Coundon. At Newland parish church, Gloucestershire, is the Miner's Brass. Inset in the tomb of Robert and Jane Greyndour, this small brass relief depicts a miner in 14th Century costume carrying a pick, a hod over his shoulder and a candle to work by. The figure appears as the crest of a helmet, supposedly the crest of the Greyndour family, but unfortunately neither the miner nor the crest is fully authenticated so its origin and age remain a mystery. If it is what it seems, it must be the earliest known British mining image.

b.

The large panoramic landscape of Harraton Hall and Lumley Castle painted by Peter Hartover in 1680, should be considered the seminal image of the Industrial Revolution. This claim first appears in Sir Arthur Elton's revised edition of Francis Klingender's *Art and the Industrial Revolution* published in 1968. The claim seems well founded and no serious contender for the title has turned up yet. Of the artist responsible little seems to be known save that he may have been a Dutch émigré working in this country. (Christopher Hussey has added further confusion by suggesting that Francis Barlow (1616-1702), the sporting painter, may have contributed the foreground figures.)

The picture itself is a mixture of genres, including a pastoral landscape, a hunting scene, bird painting and scenes from common life. These are all skillfully brought together presenting the viewer with a kind of narrative. The gentleman's hunting party in the foreground chase after foxes, sets hawks after a heron, and raises a covey of partridges. In the left hand middle ground, stands Harraton Hall almost pristine in its newness, but most centrally positioned is the River Wear. The banks of the river are piled high with heaps of coal from the Lambton and Harraton collieries. The keels are plying up and down the river heading to and from the sea. On the right is an endless procession of colliers with carts replenishing the coal stocks in the staithes and loading the keelboats. In what must have been a commissioned painting, Peter Hartover has managed to portray the texture of late 17th Century life in the county of Durham. It is at first appearance an innocuous view, with everything in its place and of its place. But closer inspection reveals unsuspected insight. The whole scene and activity therein depends on coal, its mining, its export, and its sale. Not one of the human pursuits portrayed is possible without it.

The 'sense' of industry in Hartover's landscape hardly matches up to our 20th Century concept of that phenomenon. The engagement of the colliers in their day-to-day business is industrious and profitable—(the Harraton colliery properties were valued at £ 3,000 per annum in 1644)—but they are not directly associated with the means of obtaining coal, or its attendant technology, they are bucolic colliers. Industry as we have come to understand it has yet to make its appearance in art, and some 70 years or so have to pass before any artist attempts to represent it. The development of coal mining techniques seems completely unrecorded in the first half of the 18th Century. It is only with the development of cast iron and the production of coke in the Coalbrookdale area of Shropshire that artistic imagination and temperament are stirred again.

Abraham Darby's (1668-1717) use of coke for the smelting of iron completely revolutionised coal's rival brother industry, iron. It forged a partnership between the two minerals that created the foundations for manufacture and technological advance. Within Shropshire, and particularly in the gorge of the Severn at Coalbrookdale, Abraham Darby found abundant supplies of exposed coking coal and had easy

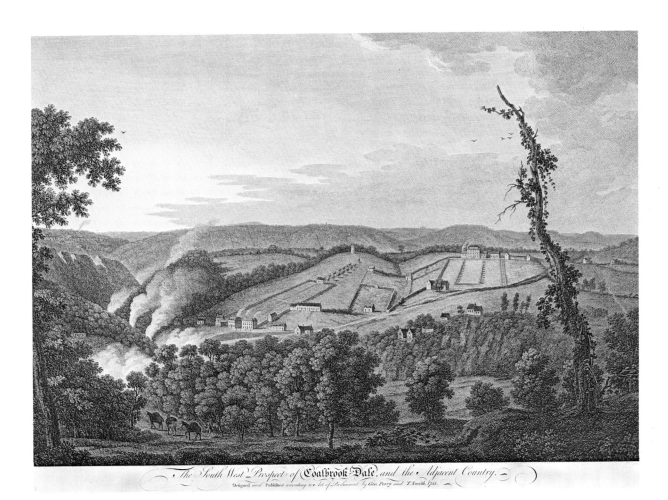

The South West Prospect of Coalbrook Dale, and the Adjacent Country.
Designed and Published according to Act of Parliament by Geo. Perry and T. Smith, 1758.

access to iron ore and limestone. With these ingredients he could smelt iron. By some extraordinary quirk of geography the Dale also possessed those elements that proved so attractive to the enquiring eyes of contemporary artists. The river, the bosky slopes, the towering cliffs and overall picturesqueness were irresistible. The rapid expansion of Darby's iron foundries and smelting furnaces had added the spectacle of large scale industry by the time more intrepid artists came to witness the scene. Iron founding is undoubtedly a much more dramatic process than coal extraction. They are, as it were, at the extremes of nature. Iron equates with heat and light, coal with damp and darkness. It is not surprising then, that the first views of Coalbrookdale picked out the smoking chimneys of riverside industry in preference to more remotely situated coal pits.

The individual watercolours and oil paintings that were produced however, are an amalgam of direct, accurate observation and an awareness of the artistic philosophies of the time. In fact the publication of the first pair of engraved views by François Vivares (1709-1780) came only one year after Edmund Burke's (1727-1797) *Inquiry into the Origin of our ideas of the Sublime and Beautiful.* These delightful prints

François Vivares
South West Prospect of Coalbrookdale, 1758
(Cat. No. 2)

derive from original line drawings by Thomas Smith of Derby (d. 1767), who was primarily a landscape painter, and George Perry an engineer. Despite frequent visits by artists to the now extensive coal and iron undertakings in and around the Severn gorge, it is 1788 before we get the first realistic representation of a coal mine.

George Robertson's (1748-1788) painting of the mouth of a coal pit near Broseley now only exists as a print published in 1788 by Francis Chesham (1741-1806). Nevertheless the sensitivity and touch of the original has been retained.

This pit is modern, it has a vertical shaft, a powerful winding mechanism, sturdy trams to carry the coal, a wooden track leading from the pit head, and a rudimentary ventilating system. The marked contrast between the industry and its setting emphasises the sense of past, present, and future within a single view. Robertson's picture, it seems, was never exhibited. His submissions to the Royal Academy consisted of three landscapes, none of which depicted industrial scenes.

It was another itinerant artist, William Williams, who took credit for the first 'industrial pictures' at the Royal Academy. His pair of paintings exhibited in 1778 portray views of Coalbrookdale in the morning and in the afternoon. In one the valley is filled with polluting smoke from the furnaces and coke hearths of the Darby enterprises. The pastoral idyll is being overtaken by the consuming need of the iron industry. It is the first inevitable step from picturesque landscape to industrial wasteland. A waggoner with his cargo of coal moves slowly down an inclined bank playing a modest part in the drama that goes on and unsuspectingly sets the seal for the future.

The poet Anna Seward (1748-1808) was also moved by the incongruity of the spectacle at Coalbrookdale. She stood in awe of the scene, surveying its power, both horrified and exhilarated at the same time. Echoing the sentiments expressed pictorially, she writes:

'Through thy coy dales; while red the countless fires...
...Darking the Summer's sun with columns large
Of thick, sulphureous smoke, which spread like palls
That scream the dead, upon the sylvan robe
Of thy aspiring rocks; pollute thy gales
And stain thy glassy waters'

Though it is true to say that Coalbrookdale, the cradle of the industrial revolution, was probably the cradle of industrial art too, it was not exclusively so. Groups of artists had begun to venture out into other regions of the British Isles in search of wild romantic scenery. What they also encountered, whilst in the company of their aristocratic patrons, was evidence of burgeoning industry in the remote parts of the country. It was on one such visit to Wales that Paul Sandby (1725-1803) must have seen the coal pit that appears in an undated painting by him. Sandby, a native of Nottingham, was by nature and training a less passionate artist than any of those who had visited Shropshire. His

vision is cool and restrained and not given to overstatement for the sake of effect. The quality and content of Sandby's drawing is praised in Thomas Gainsborough's letter to the Earl of Hardwick. He says:

'With respect to real views from Nature in this country he has never seen any place that affords a subject equal to the poorest imitations of Gaspar or Claude. Paul Sandby is the only man of genius, he believes, who has employed his pencil that way!'

It was this 'genius' that is present in his *Views in Aquatincta . . . in South Wales,* published in 1776, reproducing a series of delicate wash drawings made whilst on tour.

'Pit head of a coal mine, with horse gin' is much more robust in its approach. Sandby has used watercolour, body colour and gouache in a picture that takes us out of the sylvan idyll and into the realm of factual documentation. He has distanced himself from the immediate vicinity of the pit, to give an exact account of what he sees. We are in hilly country, populated only by those involved in the process of coal getting. The large gin winding mechanism is powered by two horses, two others stand in reserve. A knot of figures stands at the pit head beneath the well defined pulley wheels and headstock. It is a quiet, workmanlike business that is going on, the only hint of drama being the column of thick smoke that silhouettes the massive gin raising the coal from below.

Like Paul Sandby, other artists toured Wales. They were, no doubt, spurred on by the widespread circulation of his views and the stimulating writing and poetry of the time. The itinerary within Wales was well established by 1800 and it had attracted the young J.M.W. Turner (1775-1851) who made his first visit in 1792 followed by others in 1795 and in 1798. Turner came as a late witness to the rapidly developing industrialisation of the South Wales valleys. Some three years prior to Turner, the Yorkshire born artist, Julius Caesar Ibbetson (1759-1817) had already been admitted to Richard Crawshay's iron works at Penydarren and wrote to a painter friend describing his experiences. He writes;

'I was last week with my Lord at Merthyr Tydfil about 25 miles off where are the most stupendous iron works.'

He was less impressed, however, with Welsh weather. He continues:

'I visited Morlais Castle, a most Romantic situation, but it has rained incessantly ever since I came in the country'.

Ibbetson, in common with John Hassell (d. 1825), George Robertson and George Samuel(d. 1823), had preceded Turner and the continental artist Philippe Jacques de Loutherbourg (1740-1812). These artists, together with the later visitors François Louis Francia, William Havell, and John Laporte, have bequeathed a major legacy of industrial paintings and drawings that are unique in art history. Amongst them all, they managed to depict almost all the processes contributing to the early growth of Welsh enterprise. Their scenes of coal export, coal pits,

Paul Sandby,
Landscape with a Mine
c. 1775 (Cat. No 22)

copper and lead mines, iron works, forges and tilt hammers, fulling mills, water wheels, industrial housing, and steam engines, established a kind of prototype for future depictions of the industrial revolution.

By the time Ibbetson had exhibited his *'Nine views in Wales'* at the Royal Academy, and Turner had drawn his exterior perspectives of Cyfartha Ironworks, annual coal production in the British Isles had reached an estimated fifteen million tonnes. The growth and evolution of the mining industry was well under way. Statistics show that in 1800 the ports of the North East were shipping an average of over two million tonnes per year, and London was burning over a million tonnes of coal per year, At the same time Merthyr Tydfil was only four years away from its first riot. Yet the artists' view of the industry was showing very little change from that depicted in 1776. It was still being

portrayed as a rural industry without a hint of its significance to the
national economy. It is safe to say that though the content of some works
of art had changed they were still subject to influences which modified
their final appearance. The aesthetic philosophy of the time, coupled
with the yoke of patronage and the pressures of the art market,
precluded any real attempt at social realism. Truth to subject matter,
reality, or social documentation were not the order of the early 19th
Century day.

The Bradley Mine at Bilston, Staffordshire, was the subject of a pair
of lithographs published in 1805. Lithography, which developed
alongside the mezzotint and steel engraving, finally superseded them
due to its cheapness and ease of handling. The originator of the pair of
prints is unknown, but his aim in producing them is modest and they

John Laporte
*A Pithead near an
Estuary,* 1809
(Cat. No 30)

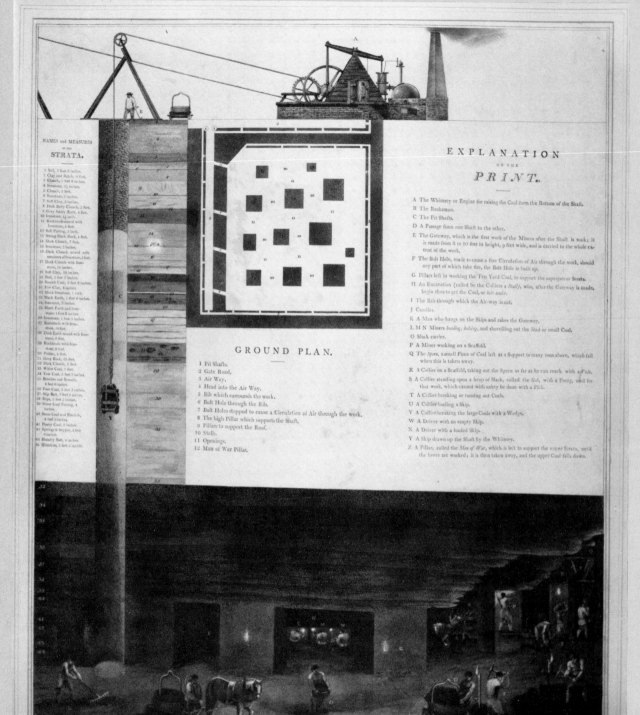

GROUND PLAN.

1 Pit Shafts.
2 Gate Road.
3 Air Way.
4 Head into the Air Way.
5 Rib which surrounds the work.
6 Bolt Hole through the Rib.
7 Bolt Holes stopped to cause a Circulation of Air through the work.
8 The high Pillar which supports the Shaft.
9 Pillars to support the Roof.
10 Stalls.
11 Opening.
12 Man of War Pillar.

EXPLANATION
OF THE
PRINT.

A The Whimsey or Engine for raising the Coal from the Bottom of the Shaft.

B The Banksman.

C The Pit Shafts.

D A Passage from one Shaft to the other.

E The Gateway, which is the first work of the Miners after the Shaft is sunk; it is made from 8 to 10 feet in height, 9 feet wide, and is carried to the whole extent of the work.

F The Bolt Hole, made to cause a free Circulation of Air through the work, should any part of which take fire, the Bolt Hole is built up.

G Pillars left in working the Ten Yard Coal, to support the superjacent Strata.

H An Excavation (called by the Colliers a Stall), who, after the Gateway is made, begin thus to get the Coal, or Side undir.

I The Rib through which the Air-way is cut.

J Candles.

K A Man who hangs on the Skips and rakes the Gateway.

L M N Miners heading, holeing, and shovelling out the Slack or small Coal.

O Slack carrier.

P A Miner working on a Scaffold.

Q The Spern, a small Piece of Coal left as a Support to many tons above, which fall when this is taken away.

R A Collier on a Scaffold, taking out the Spern as far as he can reach with a Pick.

S A Collier standing upon a heap of Slack, called the Gob, with a Prong, used for that work, which cannot with safety be done with a Pick.

T A Collier breaking or turning out Coals.

U A Collier loading a Skip.

V A Collier breaking the large Coals with a Wedge.

W A Driver with an empty Skip.

X A Driver with a loaded Skip.

Y A Skip drawn up the Shaft by the Whimsey.

Z A Pillar, called the Man of War, which is left to support the upper Strata, until the lower are worked; it is then taken away, and the upper Coal falls down.

*A Section of BRADLEY MINE, near Bilston,
shewing the various Strata, and the several operations of the Miners in getting
the Ten Yard Coal in the Staffordshire COLLIERIES.*

are without artifice. He presents us with a straightforward geological survey of the colliery, which explains the working system in the thick coal seams of Staffordshire. But as an artist he was well enough versed in the rules of perspective and figure drawing to give a sense of space and animation to the miners and machinery that are included in the diagrammatic cross-section. The range of skills and occupations in a contemporary coal mine are indicated by the beautifully articulated workers with their ant-like proportions. These delicate and sensitive prints provide an alternative view which highlight the disparity between the protocol and hierarchy of academic painting and the actuality of real life.

The proliferation of illustrative print production in the 19th Century did much to awaken interest, educate and ultimately change the popular conceptions about coal mining. Printed matter in all its various forms became the principal source of information for this increasingly complex industry, culminating in its use as a visual aid for Members of Parliament in their examination of the Commissioners' Report on the employment of children in mines.

Three illustrated publications made their appearance during the first decades of the new century. W. H. Pyne's *Microcosm*, George Walker's (d. 1795) *Costume of Yorkshire*, and William Daniell's (1769-1848) *A Voyage Round Great Britain*, were speculative ventures no doubt. But they all had elements of art, science and industry in their make up and they formed part of a growing awareness of the changing times. Of the three, George Walker's appears to be of greatest relevance. Included in the forty plates that illustrate his book is a Yorkshire miner who appears complete with a mining landscape at his back. Depicted in the drawing are a colliery with a primitive steam winder and a very early steam locomotive by John Blenkinsop pulling coal trucks. W.H. Pyne by contrast deals with collieries in volume two of his *Microcosm*. It is sandwiched between 'bird catching and rustics' in a book intended as an aid to artists for the 'embellishment' of their landscapes with figures at work. Despite sentiments expressed by Pyne that the drawings were intended to redress the aesthetic theories of the Academy, he delivers up picturesque images that owe much to Sandby and Ibbetson. His colliery is charming but positively archaic, a gin pit, described on the *Bradley Mine* lithograph of 1805 as 'old fashioned'. William Daniell's self imposed, mammoth task *A Voyage Round Great Britain* records the coastal scenery from 1813 to 1823. From the hundred drawings made, 308 aquatints were printed, and the volumes produced were sold as part works with accompanying text written by Richard Ayton, Daniell's travelling companion. Travelling north from Lands End, they finally reached Whitehaven. Here the pair parted company. Ayton visited the William Pit, then considered to be amongst the most advanced in the country, and Daniell sketched on the windswept quay. Ayton was totally

Opposite
British School,
A Section of Bradley Mine near Bilston, c. 1805
(Cat. No. 29)

Detail: **R.& D. Havell**
after Walker's *The Collier*, 1814 (Cat. No. 97)

alienated and overwhelmed by what he saw. Writing of his underground experiences he says:

'A dreariness pervades... one felt as if
beyond the bounds allocated to man or any
living being, and transported to some
hideous region unbles't by every charm that
cheers and adorns the habitable world'.

It was a sentiment obviously shared by William Daniell, as no drawing of the pit appears in the final folio. His concern for the modern feats of engineering was limited to a steamboat on the Clyde and newly erected lighthouses in Wales.

Self-censorship and the unwritten hierarchy of subject matter acceptable to the Royal Academy was breached very rarely during the first quarter of the 19th Century. With the exception of Philippe Jacques de Loutherbourg's very dramatic picture of the iron foundries of Coalbrookdale at night in 1801, artists seemed content to abide by the rules that governed public taste. Sixty-two years later a critic for the *Art Journal* was still able to categorise pictures exhibited at the summer salon under the following headings:

High Art—Sacred and Secular
Subjects Poetic and Imaginative
Portraits
Scenes Domestic—Grave and Gay
Outdoor Figures—Rude, Rustic and Refined
Animal, Fruit and Flower Painting
Sea and Landscape Painting

This grading exercise, the second public one during Victoria's reign, makes no mention of 'Industrial' genre painting, and surely any appearance of such work would have placed it securely at the bottom of any critic's list.

The first 'true' mining picture to hang in the Royal Academy must have been *'Pitmen at play near Newcastle upon Tyne: painted from Nature'* by Henry Perlee Parker (1795-1873) which was exhibited in 1836. Despite its subject matter, or perhaps because of it, the painting was well received, and must have sold almost immediately as Parker painted at least four other versions before the end of the year. He followed *'Pitmen at Play'* with *'Wives and bairns waiting the return of pitmen from work... view at Wallsend Colliery near Newcastle'* in 1837.

Henry Perlee Parker was a provincial artist of considerable talent who had adopted Newcastle as his home town for 25 years between 1815 and 1840. Seemingly a fairly progressive painter from his earliest days, his topical pictures predict the social realist subjects that became firm favourites with gallery patrons in the late Victorian period. He numbered amongst his patrons and friends, local entrepreneurs, Members of Parliament and prominent mining engineers, including Charles Brandling, John Buddle and Mathias Dunn. With these

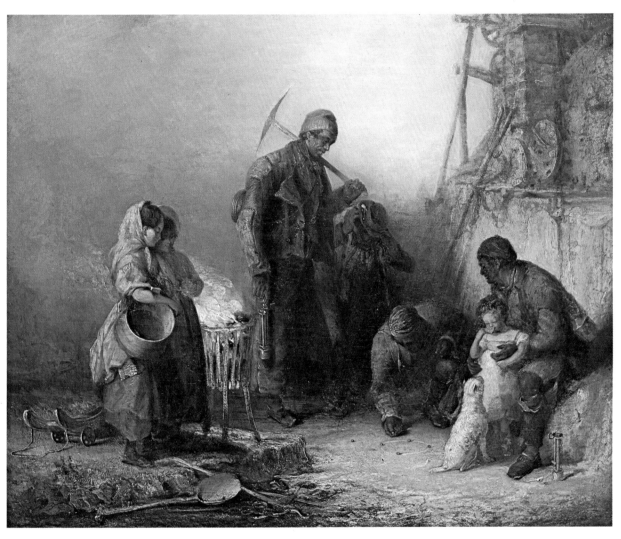

Henry Perlee Parker,
Pitmen at Play c.1836
(Cat. No. 65)

connections in the coal trade access to collieries must have been easy for Parker. His observations of the 'Geordie' pitman compare favourably with contemporary descriptions and in fact probably predate them.

Turner also exhibited a 'coal' picture at the Royal Academy, but as with all his work it is so much more than just 'coal'. *'Keelmen Heaving in*

J.M.W.Turner,
Keelmen Heaving in Coals by Moonlight,
National Gallery of Art, Washington

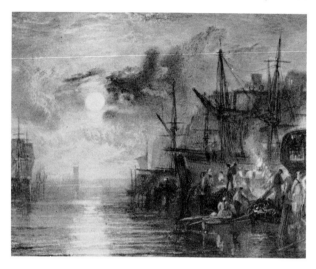

Coals by Moonlight' preceded Parker's genre piece by one year. Scholars place it amongst the late paintings which reflect the great range of interests that Turner had pursued in earlier years. It certainly has its roots in a brilliant watercolour study of, *Shields on the River Tyne,* painted in 1823. Both oil and watercolour are moonlight scenes of the coal shipping trade carried on from the banks of the Tyne. They are also a celebration of the coal heavers' trade, and the prosperity of the North Eastern coalfield, as by 1845 coal shipments from the coalfield had reached four million tonnes and output was of the order of eight million tonnes.

Coal was beginning to represent the power behind all material and technological developments. Progress, with all its benefits and drawbacks, seemed to be in the hands of the collier or coal owner. This isolated and insular activity had given rise to the improvement and introduction of steam locomotion and commercial railways, the founding of workers' unions, the first industrial disaster with over one hundred deaths, the invention of the safety lamp, and parliamentary involvement in enquiring into the employment of children underground.

If *'Pitmen'* and *'Keelmen'* project two perspectives of coal mining, they also stand as symbols of change and momentum. Henry Perlee Parker provides the detail and J.M.W. Turner the essence of the power which caused that change. Coming as they do, just before the most dynamic phase in coal mining history, these pictures are the culmination of a series of unrelated, and largely unseen, images.

Although the consciousness of the art historian was not deeply impressed by these earlier efforts, they remain vital evidence for a fuller understanding of the *'art'* of coal mining.

It was inevitable that the earliest references to names and places should occur in the work of provincial artists who practised in or near the coalfields. The tradition established by the itinerant painters of the

Follower of
Thomas Bewick,
Coal Staithes c 1800

late 18th Century was taken up on an individual basis by less well known academicians, inexperienced artists, and established genre painters who used the subject within the context of their own work. William Beilby (1744-1817), Thomas Bewick (1753-1828) and Luke Clennell (1781-1840), all living in or around Newcastle, made drawings, engravings and watercolours of the relatively advanced coal mines of Northumberland.

Bewick's minute vignettes of the Tyneside pits show smoking engine house chimneys, coal staithes, pitmen and their families and even, what may well prove to be, the earliest underground drawing of coal face work. Beilby drew the plates for Jean Morand's *'L'art d'Exploiter des mines de Charbon de Terre'* (1768-1776), and Clennell's prosaic *'Coal Staithes on the Tyne'* is masterly in its objectivity.

The South Wales miner is represented in the role of rioter by Penry Williams and his northern counterpart as the rescued victim of a disaster at Minera Mine, Wrexham by Albin Burt (1784-1842). The Earl of Dudley's collieries in Staffordshire appear in the sketchbooks of David Cox (1783-1859), who made drawings whilst on an underground visit in 1814.

The marine painters led by Dominic Serres (1722-1793), Robert Dodd (1748-1815) William Joy (1803-1857) and Edward William Cooke (1811-1880) painted seascapes with collier brigs discharging, shortening sail, leaving harbour and beating against the wind, without moving away from their normal academic pursuits. John Constable (1776-1837) and J.M.W. Turner provide atmosphere and drama;

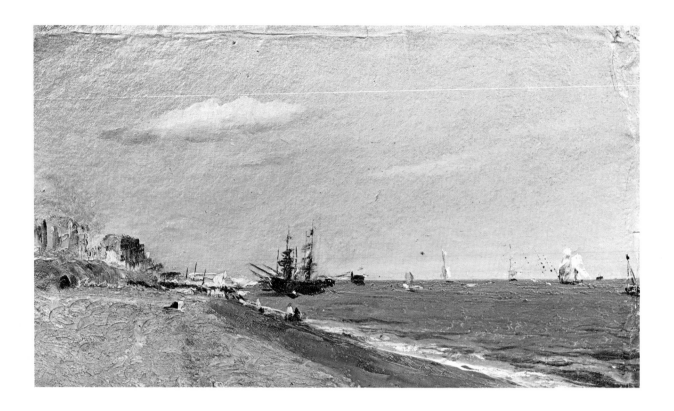

John Constable,
Brighton beach with Collier 1824
(Cat. No. 5)

'Brighton Beach with Collier' in 1824 links the north and south of England and the range of the coastal coal trade, whilst numerous diminutive pencil drawings in the British Museum's Turner Collection refer to the carriage of coal on canals in Yorkshire, Worcestershire and its everyday loss in the wrecked and beached brigs that litter his watercolours of the east coast.

The prize for confronting head-on the full visual impact of the early colliery, must lie with the unattributed painting now in the collection of the Walker Art Gallery, Liverpool. *'Pit head of a coal mine with steam winding gear'*, 1820, has a mixture of painterly naivety and scientific sophistication that is disarmingly tranquil. It is a narrative illustration and technical exposition within one frame. Its prime virtues are simplicity and clarity and its vision is stated unequivocally. Humans and animals appear as a long queue at the pit head acting out a minor drama against the mechanical stage props of an engine, head gear, and weighing machine. A hint of power is indicated by the black smoke pouring from the boiler chimney; the umbilical winding rope connects engine, head-stocks and loading frame with one sinuous arc; an

engineer stands impassively close by. However unsophisticated this painting might be, it is nevertheless an elegy to the infant coal industry of Britain, paying tribute to the engineer, the collier and coal itself.

The publication of the *First Report of the Commissioners (Mines)* from the Children's Employment Commission in 1842 was first in more respects than the commissioners may ever have imagined. It was not only the first systematic scrutiny of coal mines and coal mining by government-appointed inspectors but was also the first parliamentary document that required diagrams and illustrations to enable it to be better comprehended. This first parliamentary paper, and particularly the graphic depictions of colliery work, were also the cause of much widespread concern and popular outcry. By the addition of some rudimentary woodcuts to the commissioners' text, Parliament had unintentionally become the champion of a new form of artistic realism which would radically change the attitudes of artists and public alike

William Collingwood Smith
View of Tynemouth
c. 1845 (Cat. No. 8)

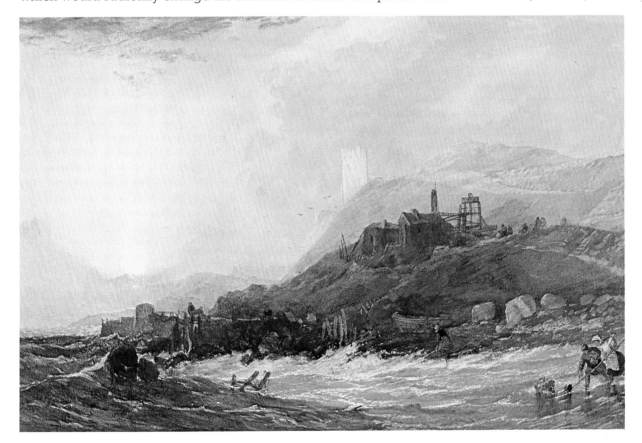

and provide the impetus for the growth of popular social documentation.

The second 'first' of 1842 was the founding of the *Illustrated London News,* a weekly magazine devoted to the provision of topical news through the media of illustrative line engravings, developed from artists' drawings done on the spot. It was the first mass circulation journal that linked its sales campaign exclusively to the proposition that pictures of high quality were the best means of communication. The *Illustrated London News* was received cautiously, but soon became the most avidly read magazine in Victorian society, and was followed very quickly by rivals of a similar nature. They all reflect the amazing range of interests that engaged the contemporary middle class, and all to a greater or lesser degree reported the tremors of social and economic change occurring in the coal mining industry.

Close on the heels of those major events came a third and much more modest 'first'. A series of *Views of the Collieries* in the counties of Northumberland and Durham was published by a relatively obscure artist, Thomas H. Hair. In common with the *Illustrated London News* and the parliamentary papers, Hair used black and white illustrations to communicate his ideas, but they were etched rather than engraved. The views were the fruit of the artist's observations in the North East from about 1837 to 1840, where he made objective watercolours of the most advanced and profitable pits. Whether Hair's publication was successful or not is difficult to estimate, but it seems to have been a good speculative gamble based on the intense interest that had been aroused.

In 1843 the explosion at Stormont Main Colliery was reported in the *Illustrated London News* with three accompanying illustrations. Two were copies from Hair and Parker; the third was a general view which took its style from Hair's drawings. It was an anodyne presentation completely out of keeping with the horror of the disaster, and it was through the text that the real story was revealed.

Availability rather than choice might well be the reason for the use of those particular engravings, and despite their rather peripheral view of the event they were the source of a visual torrent of information that flowed forth during the next fifty years. Coal mining was just one of the subjects that appeared in the thousands of engravings printed between 1843 and 1900. But by 1853 the *Illustrated London News* had published twenty engravings covering seven of the seventeen major disasters, reporting 354 of the 809 deaths that resulted from them. As early as 1844 artists were specifically employed to cover the major events of the day. The Lund Hill colliery explosion in 1857 had the dubious accolade of front page illustration. But the strike of 1873 and lock out of 1875 at Dowlais received the greatest coverage wwith seven and thirteen engravings apiece, most of which were executed by reputable artist/illustrators who were Royal Academy exhibitors. Four further engravings appeared in 1875, three depicting colliery explosions in

Yorkshire and Staffordshire, the other the Ritenbank coal cliffs as seen from an Arctic survey ship, making the total number for 1878 seventeen.

An intense rivalry existed between the *Illustrated London News* and other illustrated magazines of the period. *The Graphic* with its policy of using young socially concerned artists proved to be a serious

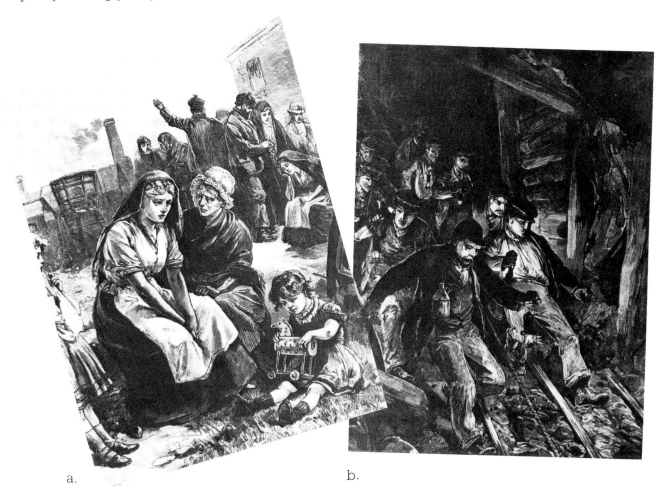

a. b.

competitor to the *Illustrated London News'* dominance and presented individual images of great strength during its early years. Both journals reflected the new influences at work in the Academy and large provincial art centres and in their turn re-influenced the work themselves. The art critic John Ruskin deplored this new tendency. He wrote in his Academy notes of 1875–

> *'The Royal Academy of England, in its annual*
> *publication is now nothing more than a large*
> *coloured 'illustrated Times' folded in saloons.'*

His opinion is very much at odds with that expressed by Vincent Van Gogh in a letter to his fellow painter Anthon Van Rappard in 1882—

a) *Pit Disaster at Parkslip Colliery*
Illustrated London News
1890s

b) **A. E. Emslie,**
A Colliery Explosion: Volunteers to the Rescue
Illustrated London News,
25 February 1882

'For me the English black and white artists are to art what Dickens is to literature. They have exactly the same sentiment, noble and healthy, and one always returns to them.'

The most scathing criticism however was served up by the critic of the *Atheneum* in 1874 in his report of the Academy Summer Exhibition. He singles out the painter Eyre Crowe (1824-1910) as one who is wasting his considerable genius in tackling subjects like *'The Dinner Hour, Wigan'* and *'A Spoil Bank.'* His commentary on *'A Spoil Bank'* ran thus:

'Another work by him though decidedly more grimy than the last, has higher claims to our attention, yet photography would have sufficed for this occasion too, as the picture is the representation of A Spoil Bank (537), one of those heaps of useless material brought up and rejected at the mouth of a coal pit, with figures. The temporary wooden frame-work which supports a railway from the pit's mouth to the end of the bank, and which is extended as the 'spoil' increases, rises high towards the front of the picture; a truck at the end of this road has been tilted, and deposits its load in a cloud of dust and smoke with abundance of noise; the whole looks harsh foul and painful. There are groups of persons, women and children who rush to obtain chance scraps of coal from the overthrown truck load, and who grovel eagerly in the dust,—five kneel in the smoke, two are in the front, one takes a can from her neighbour . . .'

he concludes:

'We admire Mr Crowe's conscientiousness in painting such uninviting subjects as these, but we submit that he might often have used his time more wisely, and that photography was made for such work as recording all that these pictures tell us, and that inferior hands might be trusted with the colour they display'.

Genre painting always had its place in academic circles, albeit a lowly one. 'Modern' genre was acceptable within fairly well defined limits, and where it was possible to combine two or more genres in a single picture the artist escaped serious criticism and often won grudging praise. Of the many thousands of genre painters who exhibited work during Victoria's reign all but a few are completely forgotten. Those who are remembered, are the ones whose subject matter is of historical or sociological interest or where the work maintains a very high quality and can be measured in terms of virtuosity.

One such picture is William Bell Scott's *'Coal and Iron,'* part of a series of pictures describing the history of Northumberland. Its style and technique are modern, its elements of history and science are

fused with contemporary industry, and its topical subject matter displays a knowledge of local, national and international events. It is a genre painting in which Scott has realistically captured the heroism of modern life.

The 'acceptable' tragedy of modern life is also expressed within the remit of 'genre' art: widowhood, the plight of orphans, sickness, disaster and death all made frequent appearances in academic painting. Mostly its outlet was through history painting, as with the *'Death of Nelson'* and similar subjects, but it soon received broader treatment particularly after the death of the Prince Consort in 1861. The high dramas of mass death and heroic rescue attempts were already

Photograph by
R. W. Downey,
Rescue Team, Hartley
Colliery Disaster
1862

commonplace illustrations in the *Illustrated London News* by the time of the Hartley entombment in 1862, so the topic was a likely candidate for the Royal Academy's Summer Exhibition.

It duly appeared with the title *'Unaccredited Heroes'* followed by a subtitle *'A Pit Mouth.'* Frederick Bacon Barwell (d. 1897) was the author of this particular piece singled out for special mention by the *Art Journal.* It was considered to be a 'powerful painting in which all propriety is sustained' and the artist had 'attempted no dramatic display' but had presented the facts 'as they must have been'. There is no evidence to suggest that Barwell had visited the Hester pit at New Hartley village in Northumberland, though many sightseers did, and not from the highest of motives. What he would have witnessed was the full drama and emotion of a futile rescue attempt that was to last ten days.

The entombment of the 204 men and boys at Hartley was caused by the snapping of the pumping engine's cast-iron beam which then crashed down the mine shaft onto the up-coming pit cage and its occupants. It further complicated matters by lodging itself half way down bringing wwith it debris that completely blocked off any escape for the colliers trapped below. All efforts at rescue by the finest pit

sinkers and mining engineers in the North East were hampered by the lack of ventilation, and on the fifth day clouds of gas escaped from the workings. On Wednesday 23rd January 1862 Queen Victoria sent a telegram declaring her hopes 'of saving the poor people in the colliery; for whom her heart bleeds'. The victims were recovered on Saturday, 25th January, and buried the next day in a mass funeral at Earsdon Church.

Hartley Colliery was extensively documented in the 19th Century; it appears in Hair's views, ten engravings appeared in the *Illustrated London News* at the time of the disaster, three further oil paintings exist, details of the internment at Earsdon are shown in a watercolour, and R. W. & D. Downey produced a photograph some days after the disaster of the master sinkers in charge of the rescue operations, standing at the pit head.

Thomas H. Hair
Hartley Colliery after the Disaster, 1869
(Cat. No. 57)

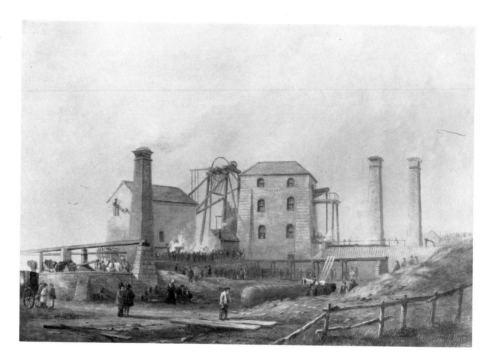

The sentimentality, mawkishness, and complacency of mid-19th Century art continued unchanged for the larger part of forty years. The revolutionary challenges of Turner remained unfulfilled; only the spirit and zeal of the Pre-Raphaelites and their associates affected any change in technique or style; realism and topicalism flourished then faded.The safe subject matter of allegory, history and literature occupied the talents of the major artists and the minor ones involved themselves in anecdote and moral narrative. In a society of almost schizophrenic extremes it is not surprising that the artists who dealt with the mining industry produced images that reflected those extremes. Year-by-year these variations manifested and established a view of the collier and

coal that grew to mythical proportions;–Heroes or Traitors–
Philanthropic benefactors or Capitalist Despots–Exotic picaresque
rogues or honest God–fearing labourers–Sailors on the Underground
Sea or Greedy loutish brutes–Liberal peace makers or Socialist agents
for change–neither artist nor agency could decide which was the truth
or fiction of the matter.

In a brief caustic introduction to *Mongst Mines and Miners*, William
Thomas, the Camborne Superintendent of Mines, makes quite plain his
opinion of artists and their rendering of the mining industry. He writes:

*'Book illustrations of underground operations and
appliances are like some drawings intended to
represent adventures in books of travel, apt to
be highly coloured, and a few sensational
pictures of miners in impossible, but to the
uninitiated 'fetching' positions have undoubtedly
often helped to promote a transaction in which
both book and buyer have been 'sold'.'*

He continues:

*'It is not however, so easy to agreeably
misrepresent the real in honest photographs'.*

Mr Thomas's comments are of course prejudiced; nevertheless
they have an element of truth in that they were rooted in direct
experience and observation of 19th Century mining. He is also adding
his name to the list of critical protagonists who attacked 'Mining' genre
art and espoused the claims of photography for reasons less pragmatic
than his. What the Camborne mine Superintendent is doing however is

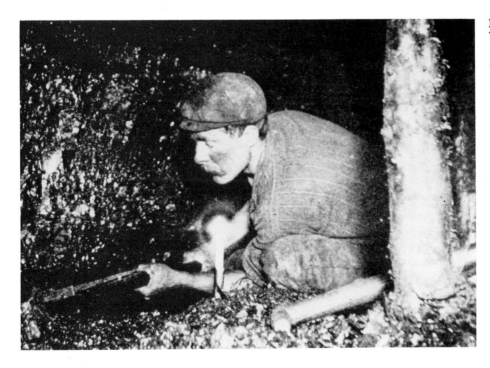

**Rev. Francis
William Cobb,**
*Underground Scene,
Brinsley Colliery,
Nottinghamshire*
1912-13

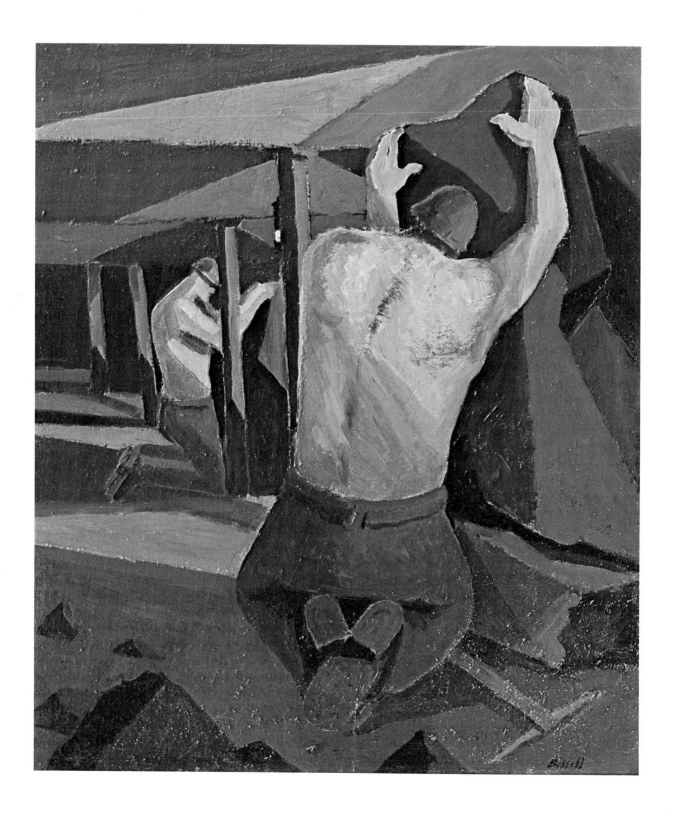

praising the virtues of his photographer friend John Charles Burrow (1852-1914), whose series of pioneering underground photographs, taken in the tin mines of Cornwall, are technical masterpieces. Burrow in his own introduction makes only modest claims for his achievement, preferring to deal with the requirements of the job in hand. He philosophically states:

'One is apt to be satisfied with the attainment
of any special object regarding it as the acme of
human effort. But there is no standing still, and
what seems perfect today will be superseded tomorrow'.

The quality of J.C. Burrow's work is undeniable; it is the fruit of his

Opposite
George Bissell
Working the Seam
c. 1930s(Cat. No. 139)

Vincent Evans
*Repairing a Main
Roadway* c. 1930s
(Cat. No. 133)

patience and precision coupled with an artist's curiosity. He was, though he may not have known it, the direct heir of Agricola, and inadvertently pointed the way for the development of mining imagery in the 20th Century. After Burrow's documentation of the tin mines of Cornwall and the coal mines of Somerset, a more realistic and informed method of representation had to be adopted.

The effect the deep mining photographers had on mining art cannot be overstated. They opened up areas rarely visited by artists or illustrators and forced a re-evaluation of work previously considered objective and accurate. It emphasised the problem that all 'coal' artists have to face, working in a darkness that is perceived and felt rather than seen. They also stand at a particular historical point with regard to our perception of the mining industry; looking back we have a wealth of visual and written observations, accumulated in the previous 200 years; looking forward we have unprecedented technical development tempered by social, political, economic, and personal persuasions.

The debate on the relationship of art and photography was enjoined almost at the instant of the latter's discovery, so the Camborne mine inspector's comments of 1893 were late additions to arguments already well documented. His comments are not unique but they do point up the special difficulties that all 'mining' artists encounter, and the problems associated with any attempt to take the subject matter beyond the purely objective standpoint.

By the time of J.C. Burrow's death in 1914, numerous photographers, professional and amateur, were conversant with almost all aspects of coal mining. One had even visited the thin seams being worked in the collieries of the Rhondda valleys, another saw the last vestiges of 'child' labour in the Somerset coalfield. The mass of material they produced provides a vivid record of the industry in the decades immediately prior to the First World War. Prints registered for copyright between 1886 and 1912 list the whole spectrum of mining images from 'Lancashire Pit-Brow Women' to the presence oof police and soldiers at Dunkerton Colliery during a strike.

The recording of the minutiae of life, for so long the province of the 'also rans' of the Academy, was very quickly taken up by the enterprising Victorian and Edwardian postcard publishers. In the fourteen years up to the outbreak of the war sales of picture cards had risen at least to 880 million; the figure relates only to those posted. These ephemeral objects, with a subject matter that ranged from the most trivial to the most horrendous, became the popular art *par excellence* of the early years of this century.

The collier at the coal face, the Wigan pit lasses, the pit pony and almost every colliery in the country seems to have appeared in the photographer's viewfinder. Not the least of these was the colliery explosion. In a specialised market that was catered for by six companies, memorial cards covering all the major disasters between 1880 and 1913 were produced in their hundreds. Benton's of Glasgow

printed a series of 22 of the explosion at Senghenydd in which 439 pitmen lost their lives.

An unidentified disaster of 1905 captured the imagination of Frank Brangwyn (1867-1956). He focused his attention on the plight of mining communities in times of stress and bereavement. In his large etching *'A Coal mine after an Explosion'*, he lifts the subject away from a concern with detail and explores the concept of suffering as a generality which occurs as a part of everyday life. The small canvas painted by L.S. Lowry (1887-1976) in 1919 is obviously drawn from personal experience. It is an intimate little study of pit people waiting for news of a local tragedy. In these art works the thread of 'mining genre' is picked up again by two artists of extreme temperaments, but what they have in common is a change of emphasis of the subject matter they portrayed. What they did echoes the thoughts of the art critic P.G. Konody predicting the need for new aspirations in painting. He wrote in the *Art Magazine* of 1903:

'The days of Olympian gods and of mythological symbolism, to which so many of our decorative artists cling with exasperating obstinacy, are over, and modern artists have to search for more motives or for adaptations of old ideas to the spirit of our time.'

P.G. Konody's *'spirit of our time'* is optimistic in outlook and reflected his view of changes taking place in European art. What is not anticipated was the scale of total change that would soon be made by the advent of war. The *war to end all wars* made irrelevant the entire scale of sensibilities held previously.

The years leading up to the First World War were predominantly prosperous but not altogether trouble free. The strikes and disputes were not always localised and sometimes of a long duration. Like the skirmishes of the 1890s they were reported and then forgotten. The benign view of all those post cards, presenting a picture of total cohesion, seemed to capture the 'spirit' of 'King Coal' perfectly. The national strike of 1912 destroyed this myth forever and supplanted it with an image that has survived to the present day. It is an image that has not radically altered, but one that has been explored and exploited, systematically and thoroughly, for many diverse reasons since its initial conception.

The 'spirit' of the miners themselves is perhaps best represented in the ideals of Keir Hardie, the pioneer socialist Member of Parliament, or alternatively in the rhyming verse chanted at union meetings up and down the country:

'Eight hours' work
Eight hours' play
Eight hours' sleep
and eight bob a day'

The 'reality' of technological change at the coal face is expressed in the work of George Bissell (1896-1973) and Vincent Evans (1894-1976).

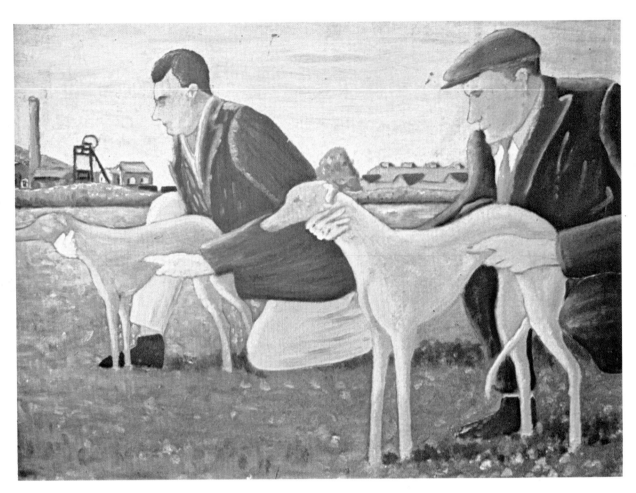

George Blessed
Whippets
(Cat. No. 72)

Both artists had personal experience as colliers at a time when 95 per cent of the record 292 million tonnes of coal produced in one year, was extracted with pick axe and shovel. Their pictures show that, despite advances, the miner had to wrench the coal from its seam by muscle power alone. They are an eloquent riposte to the heroic gestures of popular illustrators, the decorous picture post cards, and the baleful prejudices of the Camborne mines superintendent.

The tremendous social pressures of the 1920s rarely manifested themselves directly in contemporary art; only poetry and prose gave relief to those feelings of frustration, anger, misery and suffering felt by the mining communities. There are no visual equivalents to rival those of the 'New Realism' of the German artists. The challenge issued by P.G. Konody still waited to be picked up, and any sense of a personal commitment which would allow art, politics and social concern to

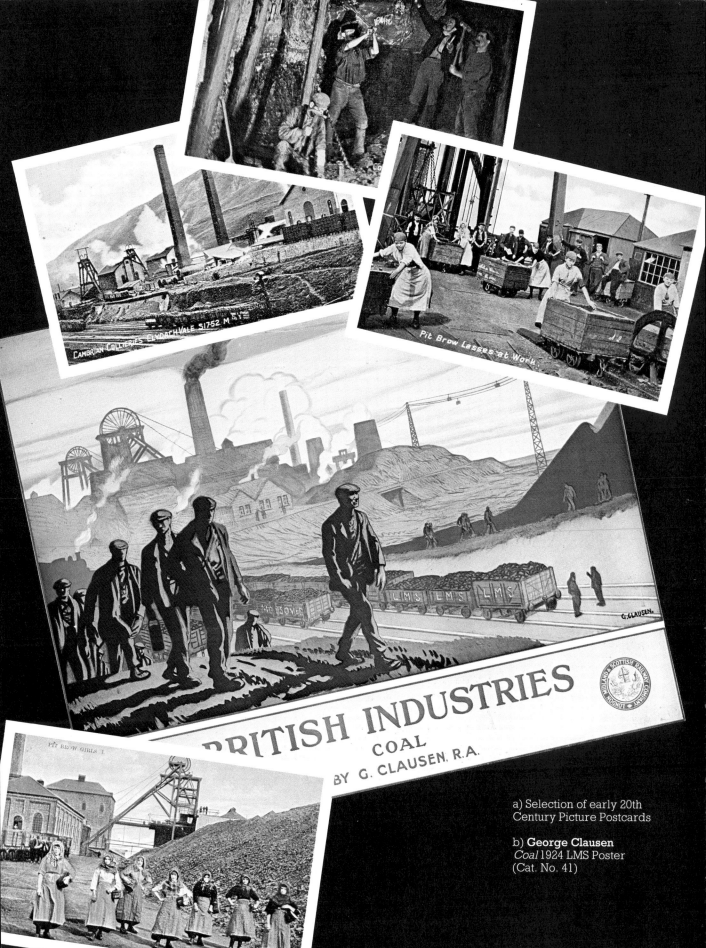

BRITISH INDUSTRIES
COAL
BY G. CLAUSEN, R.A.

a) Selection of early 20th Century Picture Postcards

b) **George Clausen**
Coal 1924 LMS Poster
(Cat. No. 41)

coalesce was entirely absent. The recorded legacy that has passed down comes only from the cartoon, documentary photograph or newsreel clip of the time.

It was the onset of the Second World War and the resultant push for increased productivity that enabled the War Artists Advisory

Bill Brandt
Coal-Searcher going home to Jarrow 1937

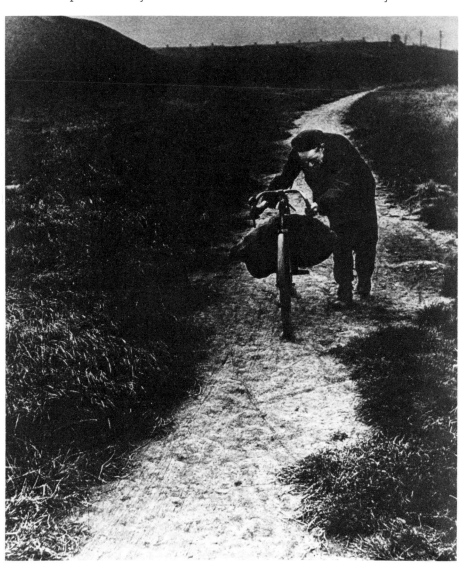

Committee to place artists in the midst of industry again. The artists' initial reluctance was quickly overcome and they were persuaded to visit the mills, mines, quarries and factories concerned in the war effort. The climate for artistic involvement was ripe once more in industries offering full time employment. The works of the war-commissioned artists had been preceded by individual and group activity in the coalfields of Britain by the documentary film crews of John Grierson, the Mass Observation Unit, the photographers Bill Brandt and Edwin

Smith and the working class pitmen painters of the Ashington Group. The 1930s had shown an upturn in interest which was given the boost it required by the official recognition of the Ministry of Information.

The Ashington Group is the name of a group of painters from the town of Ashington, a close-knit mining community situated in the North East of England. Miners were encouraged to paint in their spare-time and what they produced aroused much interest in art, and, particularly, educational circles. Ashington is unique amongst amateur art groups in that it can be identified with a concentrated culture; the paintings reflected local customs, recreational activities and the changes in working and living conditions.

Henry Moore, Graham Sutherland, Stanley Spencer and other established artists were quickly recruited as War Artists by Sir Kenneth Clark who was then the Director of the National Gallery. Both Moore and Sutherland started their wartime drawings recording city scenes. The sheltering Londoners in the tube stations caught Moore's imagination and Sutherland sat amongst the bomb-damaged buildings. Both worked directly and energetically in sketchbooks, then later re-worked their first impressions.

Herbert Read's suggestion that Moore should visit a colliery in Castleford, his home town, to explore the idea of miners working on the war effort, was reluctantly agreed to. Moore returned to Yorkshire in 1942 and whilst there made direct sketches which were enlarged and developed after he had left the pit. Sutherland reached the opencast seams at Pwll Du near Abergavenny, after spells in the steel mills of Cardiff and tin mines of Cornwall, in 1943. Both artists used the mining industry in very personal ways, making drawings that were within the brief of propaganda but never made subservient to it.

It was under the guise of propaganda that Humphrey Jennings brought together the threads of art, politics and social realism in a film that is an elegy to all mining communities. *The Silent Village* was made with the active help of the Welsh mining villages of Cwmgiedd and

a) Still from
The Silent Village 1943

b) Still from *The Cumberland Story* 1947
Both films directed by
Humphrey Jennings

a.

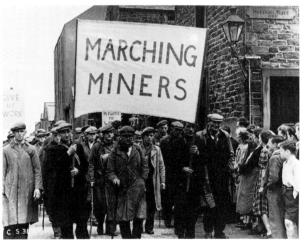

b.

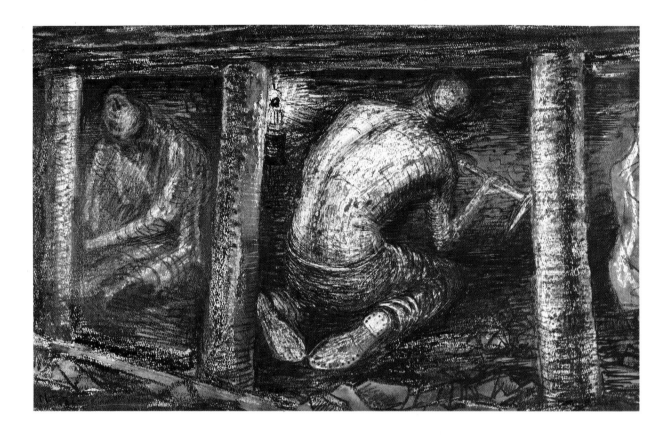

Henry Moore
Miners at Work on the Coal face, 1942
(Cat. No. 151)

Ystradgynlais and the miners who formed a film committee to help with the production of the scripts, viewed the days, rushes and criticised the film as it progressed. Jennings said some time later:

'We didn't want the film to be an inch out
 to the village–to Wales–to Lidice–
 to the miners–it's always easy to make a
 thing with even the best intentions in the
 world, and you end up by insulting them'. *

A spirit of optimistic realism breaks through in his last film for the Crown Film Unit, *A Diary for Timothy.* Here Jennings deals with the hopes for the future expressed in the aspirations of the ploughman, the sailor, and the collier, as Britain starts to reconstruct.

The flag raising ceremonies at British coal mines in January 1947 signalled the spirit of optimism present in the industry on the very first day of nationalisation. It was heralded as 'The alarm of a New Era' in which collieries were 'now managed by the National Coal Board on

* *(Lidice was a mining village in Czechoslovakia, razed to the ground, its inhabitants massacred by the Germans in 1943.)*

behalf of the people.' That morning is vividly impressed upon the
memory of Evan John the Clydach Merthyr (Swansea Valley) miner. He
recalled, in an interview with researchers from the South Wales miners'
library, his feelings on the day:

'I remember the opening ceremony of course;
raising the flag, the oldest member of the
lodge, Isaac Hill, a compresser man, he
was eighty two, and we had the youngest boy
working on the screen, and they were hauling it up together.
. . . Oh the feeling was good, you know, that
we were entering a new era'.

Graham Sutherland
Outcast Coal Production,
Depositing Earth from
Buckets 1943
(Cat. No. 45)

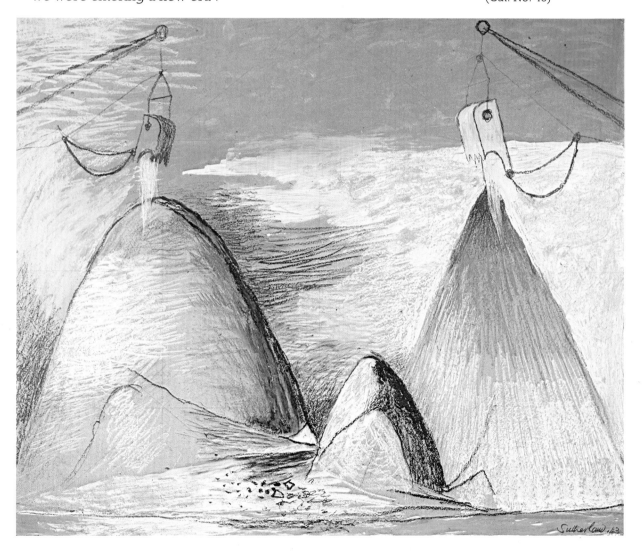

Josef Herman (b. 1911) arrived in the Swansea valleys in 1944. He came via Warsaw, Brussels and Glasgow, settled in Ystradgynlais and stayed for 11 years. The effect this small Welsh mining village had on him is remarkable. Whether choice or chance provided the catalyst, is difficult to say, but his awareness of his new situation seems immediate. In his autobiography *Related Twilights* he says:

'Every artist knows when he experiences something new.
Something that he has never experienced before. What
he may not know is the effect the experience may have
on his whole life, or how it may shape the course
of his destiny'.

Alongside Moore, Herman's images of Welsh miners are probably the most well known symbols of British mining. His sombre, rich, dark, paintings represent for most people an icon of labour embodied in the appearance of the collier. He has a reputation which is partly justified, as his canon of work is amongst the most extensive in British mining art. But the element of doubt Herman expressed about Jacob Epstein's uneasy relationship with philosophies and artistic traditions not his own, could very well apply to Herman himself. He writes:

'Every artist living in a community other than that of
his native land must expect some degree of suspicion.
After all nobody has asked him to make his home there,
he arrives with a parcel of hidden gifts that the
indigenous people are not sure they want'.

It is obvious that Herman found Ystradgynlais and its people very stimulating. But the question has to be asked, as to whether his particular vision embodies attributes completely out of keeping with the nature of the mining community he observed. For him, the community had come full circle and returned to those votive symbols of primitive religions.

Coal mining, colliers, coal strikes, pit closures and pay negotiations are the common parlance of the mass media of today. Even so, the majority of the public remains, as do the artists, outsiders to the industry. Against this background of an industry that has gone through periods of uncertainty and anxiety, followed by moods of optimism and regeneration, the artist has quietly restated his or her view.

The 'outsider' has somehow to become an 'insider' even to half understand the nature of coal mining, or the special qualities of the miner and his community. Two American photographers who managed to become 'insiders' in the Welsh mining communities in the first few years after Nationalisation were Robert Frank (b. 1924) and Eugene Smith (b. 1918). Both made statements which define personal standards of integrity that would have appealed to the consciousness of the Welsh collier in that period of new hope. Robert Frank said in 1958:

'Most of my photographs are of people. They are seen simply, as
through the eyes of the man in the street. There is one thing
the photograph must contain, the humanity of the moment. This

*kind of photography is realism. But realism is not enough–
there has to be vision, and the two together can make a good
photograph'.*

In an exhibition catalogue of 1954 Eugene Smith wrote:–
*'My principal concern is for an honesty of interpretation to be
arrived at by careful study and through the utmost possible
sensitivity of understanding. I would further, if the strength
of talent be within me, have my accomplished image transcend
literal truth by intensifying its truthful accuracy...'*

For Frank and Smith the individual is of overriding importance.
The artifacts of industry play little or no part in their pictures. They
capture the intimate moments of family life, the routines of the day, the
peripheries of the communities whose life and living depend on coal.

Two artists with an entirely different viewpoint worked in the
coalfields of Britain during the summer of 1973. Bernd and Hilla Becher
use the medium of photography as an analytical tool to investigate the
industrial structures which have been built in the 19th and 20th
Centuries. Their investigations are rigorous and formal, impassively
recording the appearance of winding towers, coal silos, and washing
plants.

The Bechers photographed collieries in the Welsh valleys nearing
the end of their economic life. The resultant pictures show these
structures, in groups of common types which point to the differences
occurring amongst them. In addition, size, scale and tonality of the
photographic print are closely controlled to exclude any intrusion

Bernd & Hilla Becher
*Coal Washing Plants and
Silos for Coal,* South
Wales 1973

which would alter the meaning of the image. These anonymous functional structures are presented as sculptural forms and they make no comment or protest concerning the mining industry or its workers.

The coal tip, that other emotive image of the mining industry, has also been a source of artistic investigation during the last decade. The Aberfan disaster of 1966 in which an infants' school was engulfed by a liquid torrent of pit waste, is indelibly etched on the minds of the South Wales communities. The immediate problem of rescue, rebuilding and reclamation of the village was documented in the photographs of Jane Bown. However, an unusual viewpoint towards coal tips is expressed in the work of John Latham (b. 1921). He nominated Carberry, one of five Bing sites, as a 'found object' and proposed that it should be developed as a sculpture (with the addition of other constructions derived from interlocked book-forms which had featured in his work of the 1950s.)

The revulsion and attraction of coal mining has affected more traditional artists as strongly. Individuals have sought to work within the industry to gain 'insight'. The National Coal Board has sponsored an 'Artist in Industry' scheme, involving young artists such as Mick Martin and Paul Butler. Ex-miners have turned to painting their experiences.

The contrast between man-made pollution and the scenic idyll are much more obvious now and of greater concern to a wider public than ever before. In the late paintings of L. S. Lowry and pictures of Prunella Clough done in the 1950s is evidence of this concern. Glen Onwin's photographic pieces show how coastal areas have been polluted by mining activity, with coal dust being washed-up on the shores.

The variety of style and content in recent mining art is plain to see. It represents an all-embracing visual record of an industry whose fortunes are never free of the public gaze. Individual approaches reflect a wide range of attitudes and these are manifested most clearly by those artists who have continued to search for the equation that will transcend mere reality. Artists involved with coal and the mining community have been profoundly moved by their experiences becoming keenly aware of a people and industry that share a strong tradition.

Douglas Gray

THE DEVELOPMENT OF THE BRITISH COAL INDUSTRY

Coal has been used in Britain as a fuel at least since Roman times and has been mined on a substantial scale for over five hundred years. The depiction of the coal industry by artists is, however, a more recent phenomenon, dating only from the late seventeenth century. This essay sketches the history of the industry over the last three centuries, reflecting the themes and developments shown in the works on display. Rather than describing the industry in modern times; the exhibition is principally about the industry as it was rather than as it is today.

Coal mining, perhaps more than any other industry, has had a central role in the development of the British economy over the last three hundred years, both in the period of rapid growth, the so-called Industrial Revolution, and in the last century or so of industrial maturity and relative decline. Coal was of fundamental importance for industrialisation, being the fuel which drove the steam engines, smelted the iron, and warmed the people. Latterly it has generated the electricity which serves industrial and domestic users in the modern world. It has also provided work for generations of men, over a million at the peak periods, and the industry is still one of the largest employers in Britain today.

Table 1: Output, Employment, Productivity

	1700	1800	1850	1913	1947	1980/81
Output (Million tonnes)	3	15	63	292	200	127
Employment (thousands) (deep mines only)	15	60	210	1,100	704	230
Productivity (tonnes/man year) (deep mines only)	200	250	300	266	266	476

Sources:
1700, 1800, 1850: Estimates from the National Coal Board's forthcoming *History of Coal industry*
1913: *Mineral Statistics*
1947: 1980/81: National Coal Board, *Report and Accounts*

As the table above shows, the industry grew from less than three million tonnes per year in the late seventeenth century, to a record output in 1913 of over 290 million tonnes. Since then output has fallen, the rate of decline accelerating in the 1960s, but in very recent years it has stabilised. The regions producing coal have, not surprisingly, changed in relative importance over the last three centuries, with new reserves being found and old ones becoming exhausted. The table (over) charts the main coalfields.

Regional Distribution of Output (Percent)

Region	1700	1800	1850	1913	1947	1980
Scotland	15	13	12	15	12	7
North East	43	30	22	20	19	12
Lancashire & North Wales	4	10	16	10	7	10*
Yorkshire	10	7	10	15	21	29
East Midland	3	5	5	12	19)	34*
West Midland	17	17	16	7	9)	
South Wales	3	11	16	20	12	7

Sources:
As table 1 * Change in regions

The North East, with its domination of the seaborne London trade, clearly surpassed all other producers until the railway age, and although the coalfield's share of output has fallen steadily, the total continued to rise until 1913. South Wales, the other main coastal region, rose in importance until the First World War as an exporting coalfield, but since then has been declining rapidly. Output in the West Midlands (principally Staffordshire) began to fall even earlier, in the last quarter of the nineteenth century, as reserves ran out. The areas of rising relative importance have been Yorkshire and the East Midlands, where new excavations into the concealed coalfield have kept up output more strongly than elsewhere since the First World War. These developments continue, with the Selby complex nearing completion, the North East Leicestershire Prospect to be pursued at least in part, and other mines even further east in the planning stages.

Employment has naturally followed a similar course to output over the same period. Manpower rose steadily to reach an all-time peak of $1\frac{1}{4}$ million in 1920. Thereafter employment declined inexorably and by Nationalisation stood at just over 700,000. The period of most rapid decline was again in the 1960s, as a severe rationalisation of the industry took place. Productivity seems to have risen from 200 or less tonnes per man/year in the late seventeenth century to about 250 tonnes in the 1800s and reached a peak of 330 tonnes in the 1880s. Thereafter productivity declined, recovered, then stagnated until after Nationalisation. In the 1960s the fruits of coalface mechanisation and rationalisation of capacity led to a fifty percent increase in output per man/year in fifteen years.

The uses to which the coal raised have been put have changed considerably over the last three hundred years, as the table shows:-

The most striking feature of this table is the rapid rise since Nationalisation of electricity generation, which now burns over two-thirds of the coal produced, compared to only 14 per cent in 1947, and

the equally dramatic slump in domestic and industrial consumption, although of course most of this electricity is used by the same groups of consumers. Other features of significance are the substantial percentage of coal output used by the iron and steel industry (which was very closely linked to the coal industry through ownership of mines up to Nationalisation) and the dramatic rise and fall of export markets. Between 1850 and 1913 exports rose dramatically, to over a third of total production. They were then halved by 1938, however, and have been relatively small since the late 1950s.

From the late eighteenth until the mid-nineteenth century much coal was simply wasted, as it was too small to be sold on the domestic market and no other use could be found for it; millions of tonnes were used to mend roads or simply burnt, especially in the North East. Ironically, output is now deliberately crushed for the power station market, though large coal still commands a premium for domestic sales.

Percentage Share of Coal Consumption

	1700	1800	1850	1913	1947	1979
Domestic	49	35	21	12	19	8
Iron & Steel	–	12	25	12	10	12
Electricity	–	–	–	2	14	67
Other Industries (inc. gas)	40	38	35	32	32	9
Colliery and Miners' Consumption, Waste etc.	8	11	12	6	8	2
Exports	3	4	7	34	3	2

Sources:
1700, 1800, 1850, 1913: *NCB History of the British Coal Industry*
1947: National Coal Board *Statistical Tables*
1979: *Digest of United Kingdom Energy Statistics 1980*

Technological Developments

Coal was won first when it outcropped on the surface. On the side of a hill this could be extracted by merely removing any topsoil and digging in along a face of a few yards until the soil above was in danger of collapsing in. This process, called 'patching' or 'bassetting' was still in use in the Welsh Valleys in the nineteenth century. The next stage from patching was to drive a drift or adit–other local names were used–along the seam as far as ventilation would allow, taking out as much of the coal as was thought safe. Such small drift mines can still be found to the present day, operated by private individuals under a licence from the National Coal Board, in areas like the Forest of Dean, generally with very little machinery.

The first shaft mines were called 'bell-pits' because of their shape. These were merely shallow shafts or wells sunk down to the coal seams

which were then excavated in all directions until the roof was in danger of collapsing and then abandoned. All such mines needed was some kind of windlass, hand or horse powered, to raise the coal and any water that might collect in them. They were rarely more than thirty feet deep; sometimes they are revealed by opencast mining or can be made out as depressions in a field. By the late seventeenth century mining reached a slightly larger scale, with deeper shafts and substantial underground workings, although there were limitations imposed by poor ventilation and lack of drainage facilities. Ventilation is needed in coal mines to remove both the stale air produced by the men working there and the two principal gases found in the mines: methane or fire damp, which causes explosions; and a carbon dioxide/nitrogen mixture, choke damp, which suffocates. Although furnaces, burning in one shaft to draw stale air out of the mine, were first tried in the seventeenth century they were not generally adopted until the mid-eighteenth century and the inability to make the workings tolerable and safe was a severe limit on the scale of the mine.

Drainage problems were a serious constraint on expansion into the deeper and wetter coal seams, which was essential if the industry was to grow. This problem was solved in the early eighteenth century by the introduction of the Newcomen pumping engine, a simple but ingenious and powerful machine which used the partial vacuum caused by condensing steam to lift the water out of the mine. Equipped wwith Newcomen engines for pumping, furnaces for ventilation, and horses and later steam engines for winding, mines could cope with most conditions and the essential features of the larger collieries remained largely unchanged until the middle of the nineteenth century.

From the 1840s mechanical ventilators, particularly fans of various types, were introduced since the increasing scale of mines, with miles of underground roadways, demanded greater flows of air than furnaces could provide. By the 1880s most districts other than the North East–where furnaces were preferred until the turn of the century-used fans for ventilation. Modern fans are mostly powered by electric motors. Allied to these improvements in ventilation, advances were made in the guiding of air through the mines, starting in the 1760s and being improved in the nineteenth century by splitting the fresh air into several currents.

The problem of firedamp mentioned above led also to the need for safer lights than the candles and oil lamps used in the eighteenth century, a problem which was solved in 1815 by Davy's and Stephenson's safety lamps. The use of these spread rapidly, although naked flame lamps were preferred where gas was not found as they gave better illumination. Electric lights were introduced in the late nineteenth century and by 1913 about 5 percent of lamps were electric. The modern cap lamp did not, however, become universal until after Nationalisation.

Safety in general was an increasing preoccupation of men, owners

Stephenson Lamp

and government alike. Explosions were the most spectacular cause of fatalities and attracted the most publicity, the worst being at Senghenydd in 1913 where 439 men lost their lives, but in most years more men died in individual accidents. Average death rates fell from over 4 per thousand men per annum around 1850 to 2.2 in the 1870s, 1.3 by 1913, 0.75 in the 1940s and as low as 0.2 in the 1970s. Better lighting, timbering, haulage systems and various other improvements all played a part in this. In the early twentieth century falls of ground, mostly at the face, were the most common cause of death, accounting for about 60 per cent of fatalities as against only 10 per cent on average from explosions. Mechanised cutting and better roof support have, however, transformed face safety so that nowadays about half the relatively low number of fatalities occur in haulage and transport.

While great advances were made in the technology which made mining possible in the eighteenth and nineteenth centuries the process of actually extracting the coal was largely unchanged: men with picks

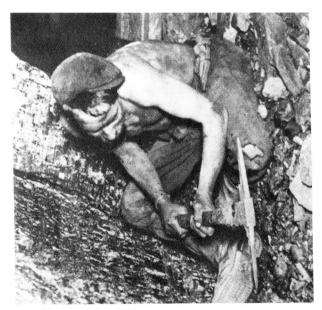 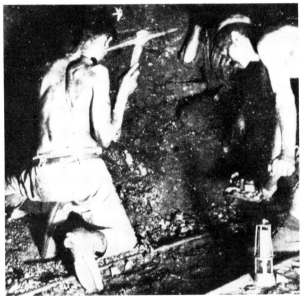

Coal Face Workers
c. 1910

and shovels cut the coal from the seam and loaded it into tubs or trucks while other men or, more commonly, boys (and, before 1842, women) took it away to be raised to the surface. The job of the hewer was onerous, and the conditions in which it was performed often atrocious. Seams as thin as 50 cm were worked, which meant the men were lying down throughout their shift. Explosives were increasingly employed after 1850 to reduce physical effort and improve productivity, but mechanised cutting was slow to come: only 9 per cent of the hardest job, the undercutting of the seam, was done by machine in 1913 and even in 1937 only half was machine undercut. Full mechanisation, using the shearer-loader which cuts the coal and puts it onto a conveyor belt, eliminating most of the hardest labour, only became general from the

late 1950s. Even in 1982 some coal is still cut and loaded by hand where conditions dictate. In former times the haulage of coal from face to pit bottom had been much more primitive, with human labour being the norm in the period up to the mid-nineteenth century. Later, especially after the prohibition of women and children from underground employment, the work was increasingly taken over by horses and by powered ropes or chains. In 1913 over 74,000 horses were at work underground, but thereafter numbers fell steadily as mechanisation became almost universal, and nowadays only a very few pit ponies are still at work, mainly in the North East.

Winding the coal to the surface was first done in basket tubs using non-mechanical power; by the early nineteenth century, however, most collieries of any size used steam power for this purpose and wound the coal in trucks of some sort, using increasingly sophisticated shaft cages to carry these and the men.

In the eighteenth and early nineteenth centuries most coal was sold untreated. Coal preparation is, however, now a vital part of the industry, although commonly taken for granted. Separation of output was first introduced in the 1770s, when the North Eastern collieries began to screen out the small coal from that destined for the domestic market by passing the run-of-mine output over bars set at a fixed distance apart. Screening gradually spread to other coalfields, and where the coal was of the requisite characteristics the small coal was generally turned into coke. In the later nineteenth century increasingly sophisticated apparatus to wash out dirt and grade the coal into various sizes was introduced, largely because washed coal fetched higher prices, although as late as 1913 only about 15 per cent of output was washed.

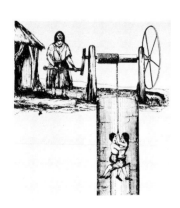

Illustration from the *Commissioners' Report,* 1842

Transport facilities are of crucial importance to the coal industry, since the product is of relatively low value compared to its bulk and is generally consumed at some distance from the colliery. The relationship has been a symbiotic one, with many of the country's canals and railways having been built for and sustained by coal traffic, and the industry has always been preoccupied with the efficient and cheap movement of its product. Before the early nineteenth century the only economically viable means of long-distance transport was by water, and by far the most important route was from the North Eastern coalfield to London and the South East by coasting vessel. These were generally of 3-400 tonnes burden and over 1,400 were in use by 1830. After 1850 steam colliers were gradually introduced but took over from sailing vessels only slowly.

As early as 1700 nearly three quarters of a million tonnes were exported by coast from the North East, more than half of this to London. The seaborne trade of London grew steadily and was only overtaken by the railways in 1867, when each brought in over 3 million tonnes; by 1913 coastal shipments, at over 9 million tonnes, were greater than rail movements again, but thereafter the trade declined, although much

49

coal still comes by sea from the North East to the Thames Estuary
power stations. Other important coastal movements of coal were from
South Wales to the South West and from the North West and Scotland to
Ireland, which were again at their peak in the period before World
War I but have since declined.

Before coal could be transported by coast it had to be taken to the
ports. This problem was solved, particularly in the North East but also
elsewhere, by the construction of waggonways and later canals.
Waggonways employed horses to haul the loaded coal trucks along
wooden plates or, later, rails. They sometimes involved journeys of ten
miles or more and considerable engineering works, as exemplified by

a.

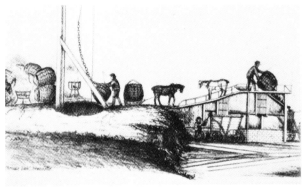

b.

Causey Arch, Britain's first major railway bridge, built in 1725. By the
end of the eighteenth century there were dozens of waggonways,
leading to rivers, canals or directly to harbours.

Canals were built from the mid-eighteenth century wherever the
terrain was suitable and the cheap transport they provided was
instrumental in allowing the inland coalfields such as those of the Black
Country, the East Midlands and Lancashire to expand. The most
celebrated and arguably the earliest was the Bridgwater Canal which
allowed the coal to be loaded in boats underground and carried to the
consumer without trans-shipment; its opening in 1761 halved the price
of coal in Manchester. The majority of over a hundred canals built
between 1770 and 1830 were associated with coal mining. The same is
true of the early railways, such as the Middleton railway near Leeds,
the Wylam Colliery tramway and the most famous of all, the Stockton
and Darlington railway, opened in 1825, which were purely local in
conception.

Longer distance transport of coal was latest in coming; the first
inland railborne coal reaching London in 1845, although thereafter the
railways rapidly took over the internal shipment of coal because of their
flexibility, reliability and economy. It has only been since the Second
World War that road transport has been used for more than local
deliveries and even today over 70 per cent of coal is carried by rail, a
great proportion in automatically loading and unloading 'merry-go-
round' trains to power stations.

a) **Etienne Fessard**
(after William Beilby)
Horses Pulling a Waggon,
1768-76
(Cat. No. 23)

b) **J. Christie**
*Coal Working in the
18th Century*
c. 1800's

Labour and the Mining Community

Because of the nature of their work and the life style it imposes, coal miners are probably the most clearly defined group of the British workforce, at least in the public perception, although their separateness from their fellow workers is generally overstated. Individual villages and towns, such as Ashington, Wombwell and the Aberaman have often had threequarters of their male workers employed in the industry. Even at the height of the nineteenth century, mining families were less than a third of the population of the coalfield areas. Equally, the job of coalmining is not as distinct as might be supposed. Mining has never been a lifetime occupation: men have entered and left the industry readily throughout the last three centuries, and have commonly been recruited from other walks of life. Even today less than half the workforce have 10 years continuous service with the National Coal Board.

The industry has nonetheless always had a firm hierarchy of skills, the top of which was the hewer and is now the skilled face worker. Promotion was generally on an age/experience basis, with a child starting as a general hand, then becoming a haulage worker and graduating to face work with adulthood, although this was by no means a fixed rule: a shortage of hewers would lead to early promotion. Surface work was generally reserved for those unable to continue underground work due to age, ill health or disablement.

The age of recruitment has risen steadily over the last 150 years. Before the 1842 Act, resulting from the report of the Children's Employment Commission, which set a minimum age of ten, children started work underground as young as five, although six to eight years old was more common. The youngest age one can work underground is now sixteen. Thousands of women also worked underground before 1842. It was the descriptions and woodcut illustrations of women's work

Illustration from the *Commissioners' Report,* 1842

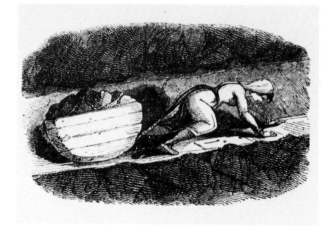

and conditions in the report of the Children's Employment Commission, as well as the moral outrage, provoked by the report, which led to their prohibition from underground work. Women continued, to be

employed on the surface in some regions after 1913. The numbers declined rapidly thereafter, although the last few 'industrial' women employees were still at work in the late 1960s.

Working conditions for men have also improved dramatically since the nineteenth century. We have already seen that fatal accidents have fallen steadily, to a very low level, thanks to new technology and to concern by government, employers and employees alike. The job of the men has also become less arduous as a result of the use of explosives and the mechanisation of cutting, loading, haulage and surface handling. The hours worked also fell from twelve to eight (plus one hour winding time) under the 1908 Act, a milestone reached after a long campaign by the mining unions. Underground hours are now $7\frac{1}{4}$ plus about half-an-hour winding time. The 5-day week was instituted in 1947: previously 6 or $5\frac{1}{2}$ day working had been the norm in many areas.

Time actually worked has always differed from set hours because of absenteeism and short working. Absenteeism, both voluntary and enforced, has always been substantial, especially in periods of high wages when it has been possible to earn enough in four days. It is clear that 'Saint Monday' (or 'Mabon's Day' as it was called in South Wales after a union leader) was a widely-taken unofficial holiday in the nineteenth century, and absenteeism ranged from about 7 to 13 per cent of possible shifts before the First World War. In the interwar years poor trade kept absenteeism low but after Nationalisation (on a different measure) it rose to as high as 19.2 per cent in one year.

Much absenteeism has, of course, been involuntary, caused by injury and illness. Miners have always been prone to occupational ill-health, because of the conditions in which they worked. Of the most crippling diseases, nystagmus (oscillation of the eyeball caused by poor lighting) has largely been eradicated in the twentieth century by the use of electric lamps, while dust related diseases (pneumoconiosis and silicosis) have been reduced dramatically in recent years by better dust control and medical care. The same applies to the other most common miners' disease, 'Beat Knee' (swollen joints caused by rubbing knees and elbows in fine dust and by cramped conditions), since mechanisation and better protective clothing have reduced the exposure to such conditions.

Miners, or at least hewers, have traditionally been among the better paid workers, although the range of earnings was wide because of the age and fitness range of the workforce. The broad trend of hewers' real earnings was steadily upwards in the nineteenth century. Wages of other workers, mostly paid on day rates, tended to follow those of hewers fairly closely, with haulage workers being paid about 75 per cent of the hewers' rate and surface employees only about half.

As well as their wages, miners have traditionally received allowances in kind, principally in the form of free or cheap coal. Equally, however, there were often deductions from wages for materials used, for

insurance and in fines for poor quality or underweight tubs, although the latter practice was outlawed in the second half of the nineteenth century. There was sometimes also an effective obligation to shop in a company-owned store (at high prices) and wages were frequently paid at least in part in 'truck', credit notes encashable only for goods. This practice was rife as late as the 1860s and '70s although outlawed by the 1831 Truck Act.

Trade unionism arrived in the collieries, as elsewhere, only slowly and on a local, hewers-only basis at first, although the high wages and grouping together of miners helped them to be in the forefront of the movement. Early unions, most notably the 1841

Miners' Demonstration in London, late 1960s

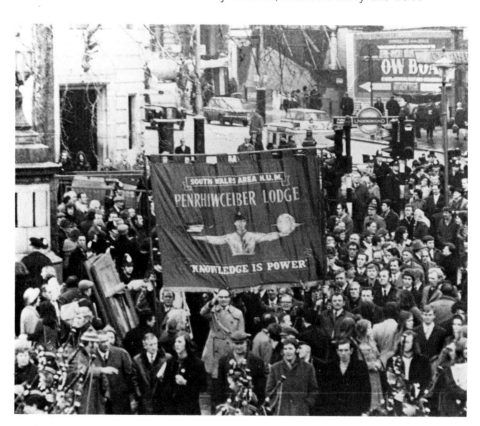

Miners' Association of Great Britain which reached 100,000 members at one point, had temporary success but failed in the face of the greater power of the owners, although the advances they fought for were gradually conceded. The latter part of the nineteenth century saw the formation in 1889 of the MFGB (Miners' Federation of Great Britain), covering all the inland coalfields and, by 1899, Scotland and South Wales. This was the forerunner of the NUM (National Union of Mineworkers). Membership grew slowly, only two-thirds of the work force being unionised in 1900, and fluctuated with the state of trade and therefore wages. This was a period of troubled labour relations, with major strikes in several years culminating in the 1912 national

stoppage in which over 31 million working days were lost. The interwar years saw the MFGB under severe pressure, especially after the failure of the General Strike, and it was only in 1945 that the NUM was established and a truly national universal, union created.

Miners' housing has, over the years, tended to be even poorer than that available to working people in general, for a variety of reasons. Many collieries were situated in rural or semi-rural areas so housing was generally in short supply and overcrowding endemic. The incentives for either the colliery owners or speculative builders to provide good quality housing was (unless they were philanthropically inclined) not especially great. Indeed, the chief motivating factor in the provision of colliery housing was generally either to attract hewers to remote areas or to exercise control over them through the sanction of eviction. The provision of 'free' housing was most widespread in the North East, in Scotland and in the newer developments in the East Midlands.

Housing standards generally have improved dramatically in the twentieth century, and colliery housing has shared in this improvement, although much older style housing is still in use, albeit uprated and refurbished. Since the 1950s the spread of car ownership has greatly modified the pattern of miners' housing, many men now commuting to work from considerable distances. Miners, at least by reputation, have always worked hard and played hard, although again one should be wary of over-generalisation. Certainly there was, especially in the eighteenth and nineteenth centuries, a good deal of drunkenness in mining communities, particularly after

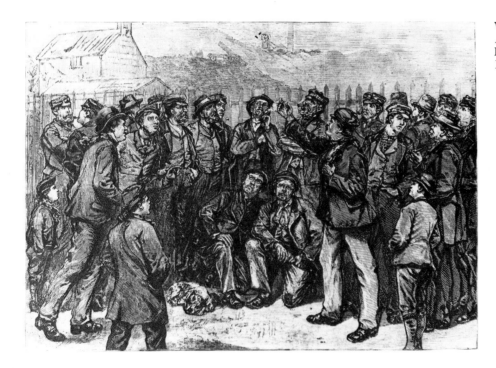

W H Overend
Pitch and Toss
Illustrated London News, 1867

paydays. It is also true to say some barbarous sports and pastimes were practiced in that period, such as cock fighting and bull baiting, but these had died out by mid-century in most areas. The Wigan miners had a particularly brutal sport called 'purring' which consisted of fighting, naked, with steel-tipped clogs.

The hard-drinking, hard-fighting image of the miner was, nonetheless, always an exaggerated stereotype and became less and less apt over time. The other leisure activities of the miners should therefore be stressed. Many, especially the married men, were keen gardeners, both for food and for pleasure. Leek and flower shows became a feature of the colliery communities in the late nineteenth century and allotments were commonly kept. Organised games and sports, particularly professional football, rugby league and rugby union, became increasingly popular over the same period and other outdoor sports such as horse, pigeon and dog racing were perennial favourites.

Among indoor pursuits, the general growth of literacy from the mid-nineteenth century was shared by the miners and reading rooms and libraries spread quickly in the coalfields. Public lectures drew large attendances, while many men found time to study at night-school. Religion, particularly non conformism in various forms and especially Methodism, was a strong moderating influence from mid-nineteenth to mid-twentieth centuries and the role of church through Sunday schools, in education and in discouraging drinking was strong.

Artistic activities also saw expression, for example through the brass bands which were started in many villages and by colliery companies; such bands as the Grimethorpe brass band today enjoy international reputations. And last but not least, many miners became interested in art, most notably the Ashington Group in the 1930s; some of whose work can be seen here.

The works of art in this exhibition trace the development of the coal industry from its small-scale beginnings to the rapid growth in the period up to the First World War and the subsequent contraction and rationalisation of output and manpower. The works show most of the operations involved from coalface to fireplace and depict the romance and the heartache of the miner's life. Above all, they show an industry confident, proud and strong, and as vital to the nation now as it was two hundred years or more ago.

John Kanefsky

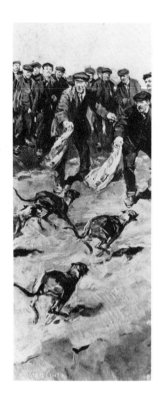

Detail:
Cyras Cuneo
Pastimes, National Strike,
Illustrated London News
1912 (Cover illustration)

CATALOGUE

1
THE MINING
LANDSCAPE

All measurements are given
in centimetres height before width.

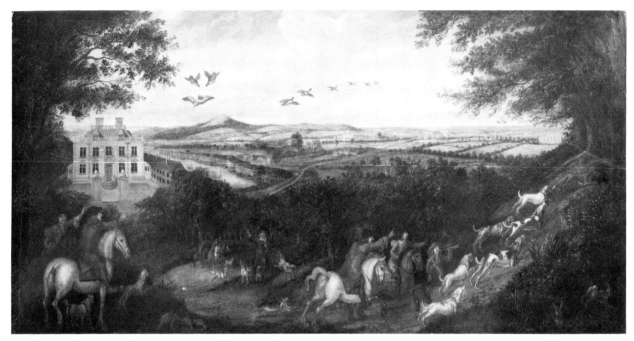

1. **Peter Hartover** △
Coal Staithes on the River Wear and Lumley Castle in the distance 1680
Oil on canvas
113.5 × 219.3
Lent by Lord Lambton

This relatively unknown artist was first introduced in Sir Arthur Elton's revised edition of 'Art and the Industrial Revolution'. His painting registers coal mining and its export via the River Wear on the Lambton estates during the last quarter of the 17th Century.

2. **François Vivares.**
(after Thomas Smith and George Perry)
South West Prospect of Coalbrookdale, 1758
Engraving, hand coloured
39 × 54.5
Lent by Ironbridge Gorge Museum Trust, Elton Coll.

3. **François Vivares**
(after Thomas Smith and George Perry)
The Upperworks at Coalbrookdale, 1758
Engraving, hand coloured
39 × 54.5
Lent by Ironbridge Gorge Museum Trust, Elton Coll.

François Vivares after Thomas Smith. These engravings present views of Coalbrookdale as it was in 1758. Vivares' well manicured fields, factories horses and hedgerows are far from the spectacle that Anna Seward described nearly 30 years later. There is only a hint of the trade in iron carried on the river and the scale of the industry seems quite diminutive. This refined and dignified narrative of the events taking place at Coalbrookdale shows nature and iron making still in harmony.

4. **William Williams**
A Morning view of Coalbrookdale, 1777
Oil on canvas
102 × 125.8
Lent by Clive House Museum, Shrewsbury

William Williams, born around 1740, submitted between 1770 and 1792 twenty-six paintings, mostly landscapes, to the Royal Academy. He visited Coalbrookdale in 1776 or 1777 and exhibited a pair of paintings at the Royal Academy, representing morning and afternoon views of the industry in the dale. Both works are topographical in style; the landscape dominates and the industry is viewed from a distance. In the 'morning view' a loaded coal waggon is held in check by a team of horses as it winds down the incline towards the pumping engine and furnace houses. This technique, similar to that used in the collieries of the North East, appears in Jean Morand's *L'art d'Exploiter les mines de Charbon de Terre* 1768-76, which shows a Newcastle coal waggon of 1773 on its journey to the river bank.

5. **John Constable**
Brighton Beach with Collier 1824
Oil on paper
13.6 × 24.7
Lent by the Victoria and Albert Museum

Brighton Beach with Collier was painted two days after the artist's arrival in Brighton. On the back of the tiny painting he wrote:
3d/tide receding/left the beach wet – Head of the Chain pier/Beach Brighton/July 19 evg 1824/My dear Maria's birthday/ Your Goddaughter –/very lovely evening–/ Looking Eastward – Cliffs/ & light of a dark gr (ey?) effect – b . . . ground – very/white & golden (?) light, colliers on the beach.
The colliers on the shore at Brighton had a particular fascination for Constable, perhaps because the shipping and retailing of coal formed part of the family business. The brigs are to be seen in a number of oil-sketches and drawings he made of the beach up until 1828.

6. **Charles Turner (after J. M. W. Turner)**
Shields on the Tyne Plate from *The Rivers of England* published by Cooke, London 1824-27
Engraving
15.4 × 21.7
Lent by the Victoria and Albert Museum

7. **Robert Dodd** ▷
A Collier Brig discharging her cargo of coal into Lighters near Limehouse
c. 1820
Oil on canvas
88.5 × 102
Lent by the National Coal Board

Robert Dodd, principally regarded as a marine painter who specialised in battle scenes. He recorded both the American War of Independence and the French Revolution. By 1800 he was living in Wapping and continued to find suitable subject-matter in and around the dockyards of Woolwich. Many of his drawings were engraved and published.

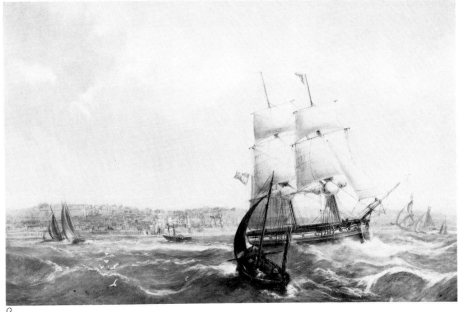

9

8. William Collingwood Smith
View of Tynemouth
c. 1845
Watercolour
36.5 × 50.5
Lent by Ironbridge Gorge Museum Trust, Elton Coll.

William Collingwood Smith, born 1815, became an Associate of the Society of Painters in Watercolours in 1836 and had also submitted his first picture to the Royal Academy in that year. Following this first success he became a regular exhibitor at the British Institution and the Academy until 1855. His *'View of Tynemouth from the North East'* was painted around 1845. Smith like Turner, depicted the collier brigs as they sailed out of the river mouth on their voyages south to the east coast ports and London.

9. William Mitchell
A Collier Brig leaving Maryport 1857
Oil on canvas
48.4 × 74.5
Lent by the National Coal Board

10. William Lionel Wyllie △
Black Diamonds c. 1890
Oil on canvas
45 × 80.5
Lent by the Coal Factors' Society

William Lionel Wyllie was a regular contributor to the British Institution and the Royal Academy during the last 20 years of the 19th Century. He painted scenes around the busy pool of London and occasionally ventured further afield to the docksides of the coal exporting ports around the British coast. Wyllie was singularly successful during the decades around the turn of the century, finding commissions and patronage from shipping companies, coal exporters and the Royal Navy.

11. Edward Wadsworth
Windmill End 1919
Indian ink
24.7 × 33
Lent by City of Manchester Art Galleries

In 1920 the Leicester Gallery exhibited a suite of drawings made by Wadsworth on a tour of the Black Country. Wadsworth's spiky angular drawings of the Black Country industry was later published as a book by the Ovid Press with an introduction by Arnold Bennett. This included *'Windmill End'*, a drawing from the suite, showing a 'classical' colliery tip accompanied by its pit and an inclined plane tramway.

12. L. S. Lowry ▷
New Town Pit c. 1920
Oil on canvas
24.2 × 39.4
Lent by Dr Peter Phillips

13. L. S. Lowry ▷
Industrial Landscape, River Scene 1935
Oil on canvas
37.5 × 51.4
Lent by the Laing Art Gallery, Tyne and Wear County Council Museums

L. S. Lowry's paintings of Salford, Manchester and those unnamed Lancashire mill towns must be the most familiar of all industrial pictures. His long life and constant output are centred almost entirely on what have became archetypal images of working class life. His references to the actual nature of work or industry are never very specific save on very few occasions. His incidental recording of coal mining are even rarer despite the

almost legendary stories of Wigan collieries and Wigan pit girls. In 1920 he made fine, linear drawings of the Wet Earth colliery at Swinton. As his career progressed and his style changed, collieries and pit head gear became parts of larger generalised industrial skylines. In 1965 he made one of his rare visits to South Wales which resulted in a large painting of the Monmouthshire valleys, coal town, 'Bargoed'.

14. **John Piper** ▷
Coaling Cardiff 1945
Watercolour
53.5 × 69.2
Lent by the National
Museum of Wales

'Coaling Cardiff' is one of
a series of pictures
painted by Piper during
the period when he was
employed by the
organisers of the
Recording Britain scheme
and by the Ministry of
Information for their
propaganda series *Britain
in Pictures*. Piper was also
coming to the end of his
commission as an Official
War Artist. Like Moore,
Sutherland and Spencer,
he had concentrated his
energies on depicting the
war effort on the home
front.

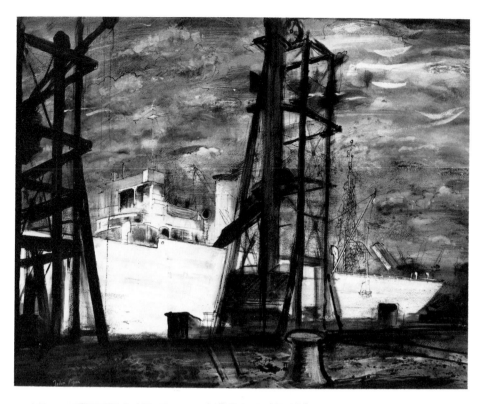

15 **Prunella Clough** ▷
*Industrial Landscape in
Mining Area* 1956
Oil on canvas
58.4 × 78.7
Lent by Sheffield City Art
Galleries

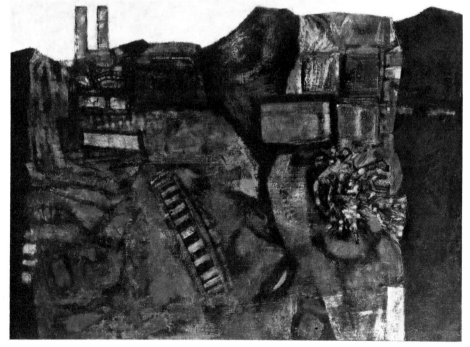

16. **Glen Onwin**
Sea Coal Seafield 1974-75
six photographs
40.5 × 51 each
Lent by Glen Onwin

17. **Glen Onwin**
Coal Measures 1976
mixed media
four panels, 107.5 × 107.5
each
Lent by Glen Onwin

18. **John Latham** ▽
Carberry Bing 1976
Photographs, mixed
media
121.9 × 182.9 × 25
Lent by the Arts Council

'Carberry Bing' was
intended to be shown with
another work by the artist
consisting of interlocked
book-forms displayed
horizontally at eye-level in
front of the *Carberry*
piece.
The book-forms feature as
part of Latham's scheme to
develop the Bing sites into
sculpture. Reconstructed
elements of the book-
forms would be added to
the existing coal tips.

19. **Michael Martin** △
*Dog in a Mining
Landscape* 1980
Oil on canvas
121.3 × 91.5
Lent by Michael Martin

20. **Michael Martin**
Study of Sharlston, 5.30 am
January 1980
Charcoal, pastel and conté
33.3 × 49.5
Lent by Michael Martin

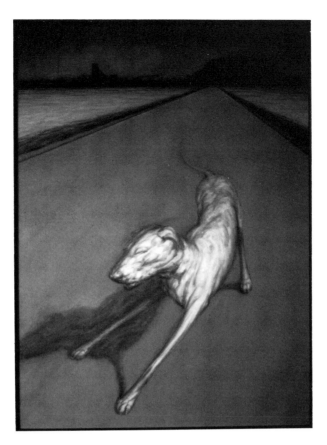

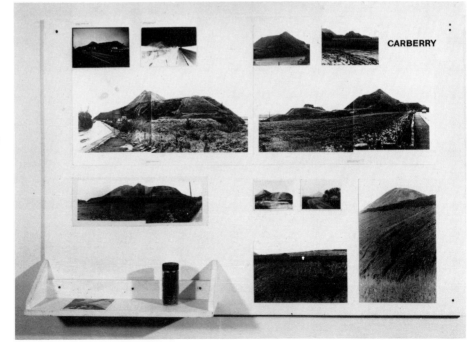

2
THE COLLIERY
CLOSE - UP

21. Thomas Dineley ▷
Progress of the Duke of Beaufort through Wales
1684
A facsmile copy of 1888
Printed book bound in
cloth
29 × 23 × 6
Lent by the National
Library of Wales

22. Paul Sandby
Landscape with a Mine
c. 1775
Gouache
24.8 × 33
Lent by the National
Museum of Wales

23. Etienne Fessard (after
William Beilby)
*Horses Pulling a Coal
Waggon*
Plate from Jean Morand's
*L'art d'Exploiter les mines
de Charbon de Terre*
1768-76
Engraving
Lent by Ironbridge Gorge
Museum Trust, Elton Coll.

24. Etienne Fessard (after
William Beilby)
*Women Working on the
Surface*
Plate from Jean Morand's
*L'art d'Exploiter les mines
de Charbon de Terre*
1768-76
Engraving
Lent by Ironbridge Gorge
Museum Trust, Elton Coll.

25. John Hassell ▷
A view near Neath 1788
Engraving
31 × 32.7
Lent by Ironbridge Gorge
Museum
Trust, Elton Coll.

John Hassell's coloured
aquatint of 1788 places
coal mining
geographically and also
includes references to
both primitive and more
modern technology. The
pumping engine on the
right is used for draining
the mine of water, the pit
shaft is roofed by

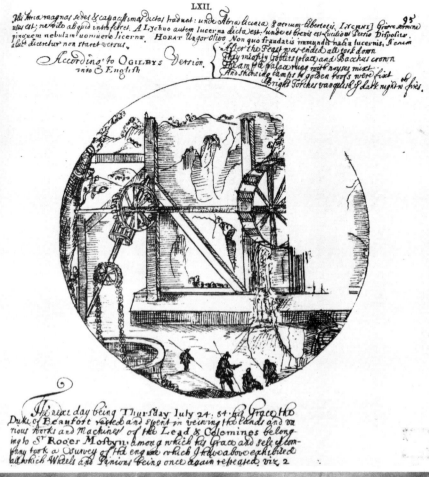

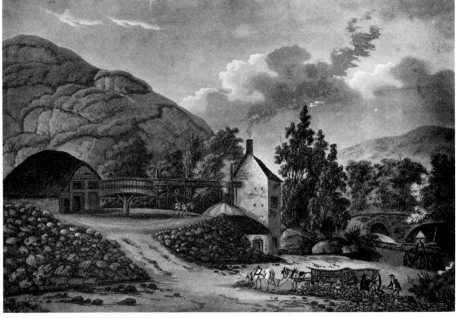

traditional thatch, and a horse gin is used to raise the coal to the surface. The artist has chosen elements of industry that did not conflict with the ideals of the picturesque and the topographical tradition. His other views of quarries, coal works, and lime kilns also show the rustic fused with the modern in a harmonious way.

26. Julius Caesar Ibbotson
Coal Mine c. 1790s ▷
Watercolour
10 × 16
Lent by Sir William
Rees-Mogg

27. John Sell Cotman
*Coal Shaft at
Coalbrookdale* 1802
Pencil and wash
21.9 × 32.6
Lent by Leeds City Art
Galleries

John Sell Cotman's reaction to industry was specific. Although he and Munn must have worked from almost identical positions their interpretations could not have been more dissimilar. Cotman avoided the distanced cool appraisal of the scene, he chose the closer, the dynamic, the atmospheric to represent his impression of early 19th Century industry.

28. P. S. Munn ▷
Great Wheel at Broseley
Watercolour
31.5 × 20.7
Lent by Ironbridge Gorge
Museum Trust, Elton Coll.

Paul Sandby Munn, the godson of Paul Sandby passed through Coalbrookdale in 1802, in the company of John Sell Cotman. Both artists were enormously impressed by the sight of the industry in

the gorge. Munn made meticulous studies of the bridge, lime kilns, foundries and coal mines. But only in two drawings does he capture any sense of drama, *'Bedlam Furnace'* (almost an exact replica of de Loutherbourgs' picture exhibited in 1801 *'The Great Wheel at Broseley'*).

29. **British School**
A Section of Bradley Mine near Bilston c. 1805
Engraving
59 × 45.8
Lent by the Coal Factors' Society

29A. **J. Westwood** ▷
A Perspective Plan and Section of a Coal Work
1806
Engraving
44.5 × 60.6
Lent by the Coal Factors' Society

30. **John Laporte**
A Pithead near an Estuary
1809
Watercolour
31.4 × 43.5
Ironbridge Gorge Museum Trust, Elton Coll.

John Laporte, born 1761, was a topographical artist working in London at the turn of the 18th Century and known for his picturesque views of the Lake District and Snowdonia. *'Pithead near an Estuary'* is signed and dated 1809 and is most probably a scene in South Wales. The proximity of the pit to harbour facilities may well place Laporte's picture in the Britton Ferry/Swansea neighbourhood.

31. **Theodore Major**
Pit at Wigan 1950
Oil on canvas
51.2 × 61.3
Lent by the City of Salford Art Gallery

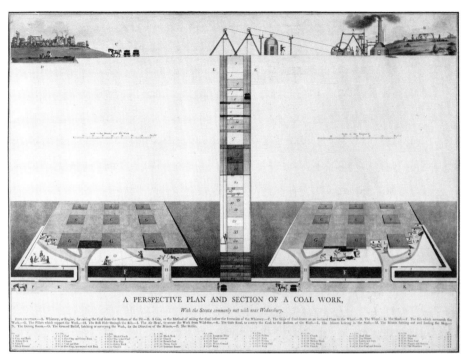

A PERSPECTIVE PLAN AND SECTION OF A COAL WORK,
With the Strata commonly met with near Wednesbury.

32. **British School**
Pithead of Coalmine with Steam winding Gear
c. 1820
Oil on canvas
95 × 153
Lent by the Walker Art Gallery, Liverpool

33. **Théodore Géricault**
The Coal Waggon 1821
Lithograph
19 × 30.9
Lent by the Coal Factors' Society

34. **Thomas H. Hair** ▷
Sketches of the Coal mines in Northumberland & Durham, 1839-1846
Thirty-eight watercolours each approximately
30.5 × 23
Lent by the Department of Mining Engineering, University of Newcastle upon Tyne

The period between 1830 and 1840 when Hair completed most of his watercolours of collieries in Northumberland and Durham was an

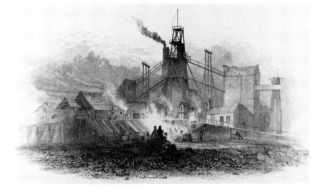

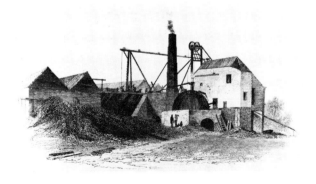

interesting one in the history of the coal trade in the North East. Activity in the collieries in the Tyne basin was diminishing due to ever increasing mining difficulties. Development was taking place further north, along the east side of Durham and in the South-West of the same county.

A series of etchings was made from the watercolours and this album was first published in London in 1839.

35. J. M. Carmichael
Northumberland Colliery
1840
Watercolour
25.8 × 37.2
Lent by Ironbridge Gorge Museum Trust, Elton Coll.

36. W. Wheldon
Mining Landscape c. 1840
Oil on canvas
28 × 46
Lent by the Science Museum

37. W. Wheldon
Mining Landscape c. 1840
Oil on canvas
28 × 46
Lent by the Science Museum

Two mining landscapes in the manner of T. H. Hair, painted in oils. Lively detailed pictures probably of collieries in the North East. They are the work of a competent journeyman artist.

38. T. M. Richardson △
North Eastern Colliery, Murton 1841
Watercolour
42.5 × 28
Lent by Tyne and Wear County Council Museums

Thomas Miles Richardson was a contemporary of H. P. Parker and J. W. Carmichael who also practised in Newcastle. He

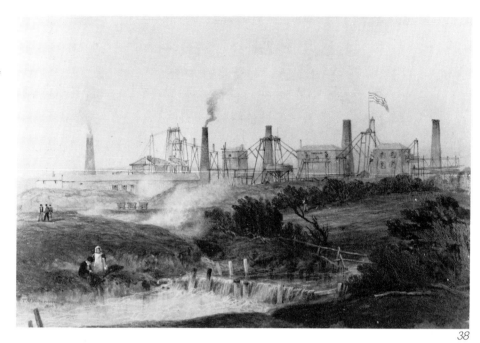

38

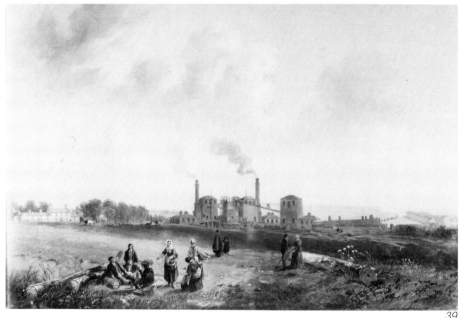

39

is generally regarded as a painter of local scenes but his work has a fairly full range and includes pictures of the developing railway system and quayside views on the Tyne. He was instrumental, together with Parker, in the setting up of the Northumberland Institution for the promotion of the Fine Arts and was also a regular exhibitor at the Royal Academy and Scottish Academy.

39. J. M. Carmichael △
Murton Colliery 1843
Oil on canvas
60 × 91.5
Lent by Sunderland Museum and Art Gallery, Tyne and Wear County Council Museums

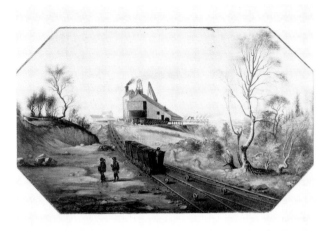

36

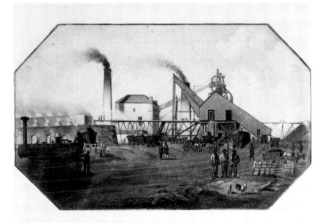

37

John Wilson Carmichael, born 1800, was primarily a marine painter. He is probably best known outside the North East for a series of wash drawings, of *Views of the Newcastle and Carlisle Railway* engraved by J. W. Archer. Two colliery pictures by the artist are also known to exist, the larger one, an oil painting is of *Murton Colliery* dated 1843. He made a sepia drawing of a Northumberland colliery in 1840. The pit at Murton was associated with trade unionism from its inception and was involved with the founding of the Durham Miners' Association.

40. **L. S. Lowry** ▽
Wet Earth Colliery 1929
Pencil
24.3 × 34.3
Lent by the City of Salford Art Gallery

41. **George Clausen**
Coal 1924, LMS Poster Paper
101.6 × 127
Lent by the National Railway Museum

42. **N. Wilkinson**
A Midland Coalfield
c. 1930, LMS Poster Paper
101.6 × 127
Lent by the National Railway Museum

43. **H. Wilson**
Ashington Colliery c. 1940
Oil on board
50 × 65
Lent by the Trustees of the Ashington Group

44. **Graham Sutherland**
Outcast Coal Production, Side of Pit Scald by Dragline, 1943
Watercolour and ink
42.2 × 30.2
Lent by the Visitors of the Ashmolean Museum

45. **Graham Sutherland**
Outcast Coal Production, depositing earth from buckets 1943
Gouache and crayon on hardboard
70.5 × 86.2
Lent by Aberdeen Art Gallery and Museums

After drawing and painting scenes of bomb damage in Swansea and London, Sutherland, as an Official War Artist, moved on to the tin mines of Cornwall, the steel mills of Cardiff, the open cast coal seams near Abergavenny and the limestone quarries of Derbyshire. In this way he dealt with the raw materials so necessary to the war effort. The series of drawings originating from the direct observation of opencast mining at Pwll du, an area of Gwent that lies in the shadow of the Blorenge mountain, depicts a landscape showing the folded contours above Blaenavon that are now littered with the waste products of abandoned mines.

46. Charles William Brown
Pit head 1943
Watercolour and ink
28.9 × 22.3
Lent by the City Museum
and Art Gallery, Stoke-on-
Trent

47. Bernd & Hilla Becher
*Great Western Colliery
Ponty Pridd, South Wales*
1968
Photographs
28.5 × 58.2
Lent by Leeds City Art
Galleries

**48. & A Bernd & Hilla
Becher**
18 Pitheads
Photographs
25 × 20 each
Private Collection

During the past three
decades Bernd and Hilla
Becher have been
systematically recording,
through means of
photography, various
types of industrial
structures in Europe.
Their work explores the
relationship between
function and image.

LMS **A MIDLAND COALFIELD**
BY
NORMAN WILKINSON, R.I.

42

44

3

PIT PEOPLE:
PERSONALITIES
AND EVENTS

The Considerate Coal Merchant!

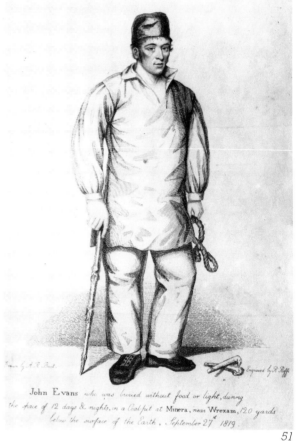

John Evans *who was buried without food or light, during the space of 12 days & nights, in a Coal pit at Minera, near Wrexam, 120 yards below the surface of the Earth, September 27th 1819.*

51

49. **British School** △
*The Considerate Coal
Merchant* 1802
Engraving
26.5 × 32
Lent by the Coal Factors'
Society

50. **British School**
The Coal Contractor 1806
Engraving
24.9 × 35.2
Lent by the Coal Factors'
Society

51. **R. C. Roffe** (after
R. Burt)
Portrait of John Evans 1819
Engraving
24.8 × 16.5
Lent by the
National Museum of Wales

The cryptic caption below
the engraved portrait of
John Evans, outlines the
ordeal he suffered. It says:
 John Evans who was
buried without food or
light, during the space of
12 days and nights, in a
coal pit at Minera, near
Wrexham 120
yards/below the surface of
the earth, September 27th
1819.
Albin Robert Burt born
1783, was a successful
portrait miniaturist.
Although he exhibited at

the Royal Academy in
1807 and 1830 his real
patronage came from the
provincial centres of
England. The image of
mining heroism and
forbearance was to be
developed and later
flourish in the illustrated
weekly journals in the
second half of the 19th
Century.

52

52. **Penry Williams**
Arrival of the Troops during the riots of Merthyr 1816 c. 1820
Oil on canvas
38.1 × 53.4
Lent by Merthyr Tydfil Borough Council

Penry Williams, born 1802 attended the Royal Academy schools, but Williams left Britain in 1826 to join the colony of British painters in Rome and to pursue his career as a landscape painter. His depiction of the second Merthyr riot of 1816 is an unusual subject and one that involved miners and iron workers protesting at the prospect of lower wages and unemployment. A series of skirmishes between the workmen and their employers led to the use of militiamen and cavalry from Cardiff, Newport and Swansea. Involving workers from neighbouring iron works and collieries, the disturbances spread to the South Wales Coalfield. But Penry Williams' early painting stands as a unique visual narrative of the event.

53. **John Leech**
Capital and Labour
Punch, Cartoon No. V
1843
Engraving
Lent by Leicester Polytechnic

54. **David Roberts** ▽
Opening of the New Coal Exchange 1849
Oil on canvas
35 × 113.5
Lent by the Coal Factors' Society

David Roberts, born in Edinburgh in 1796, started his artistic career as a scenery painter, first in Scotland then in Drury Lane, London. He is best known for his exotic architectural and landscape paintings of the Near East and temple ruins. He was a regular exhibitor at the London galleries and a founder member of the Society of British Artists. The New Coal Exchange was opened by the Prince Consort, 30th October 1849.

55. **William Bell Scott**
Iron and Coal 1861
Oil on canvas
185.4 × 185.4
Lent by the National Trust, Northumbria

56. **John Henry Leonard**
Burial of the victims of the Hartley Colliery Disaster in Earsdon Churchyard
1862
Watercolour
25.9 × 36.4
Lent by the Laing Art Gallery, Tyne and Wear County Council Museums

John Henry Leonard, born in Yorkshire in 1834 was a landscape and architectural painter and studied there under William Moore but later moved to London where he lived till his death. From 1886 he was Professor of Landscape Painting at Queen's College. The painting exhibited is similar in appearance to an engraving appearing in the *Illustrated London News* at the time of the disaster.

57. **Thomas H. Hair**
Hartley Colliery after the Disaster 1869
Oil on canvas
35.9 × 50.8
Lent by the Laing Art Gallery, Tyne and Wear County Council Museums

58. **J. Robson**
The Hartley Men 1862,
1930
Oil on canvas
79.4 × 104.5
Lent by South Shields Museum and Art Gallery, Tyne and Wear County Council Museums

59. **Francis Holl**
The Stephenson Family - Birthplace of the Locomotive c. 1862
Engraving
95 × 61
Lent by Ironbridge Gorge Museum Trust, Elton Coll.

60. **Francis S. Walker** △
Tip Girls
Illustrated London News
February 27 1875
Engraving
Lent by Leicester Polytechnic

63

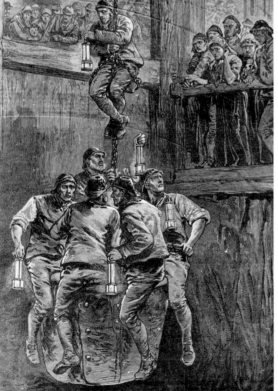

61. W. H. Overend ◁
Colliery Disaster at Seaham
Illustrated London News
September 18 1880
Engraving
Lent by Leicester
Polytechnic

62. Hannah Keen △
Portrait of a Pit Brow Girl
1895
Oil on canvas
41.3 × 31.8
Lent by William R. Hill

This painting by Hannah
Keen, an amateur artist,
dates from 1895 and is
most likely a portrait of
one of the girls working at
the Maypole colliery, as
Hannah's father, James
Keen, was Chairman of the
Wigan Coal and Iron
Company, the owners of
the colliery. It relates to a
painting of the same
subject by Arthur Wasse,
painted in 1887 and the

earlier photography of A.
J. Munby. It is predated by
an established genre of
'pit girls' that appeared
frequently in the work of
the Belgian social realist
artists, Constantin
Meunier, (1831-1905),
Armand Rassenfosse
(1861-1934) and Cecile
Donard (1866-1941).

63. Sylvia Pankhurst
*Portrait of James Keir
Hardie,* before 1910
Watercolour
37.1 × 26.7
Lent by the
National Portrait Gallery

Sylvia Pankhurst was a
student at the Royal
College of Art. It was
probably whilst she was
there that she made the
two preparatory portrait
studies of the old miner
whom she had first met
when she was 11 years
old.

64. **Henry Perlee Parker** ▷
Pitmen playing quoits c. 1836
Oil on canvas
82 × 69.5
Lent by the Laing Art Gallery, Tyne and Wear County Council Museums

65. **Henry Perlee Parker**
Pitmen at Play c. 1836
Oil on canvas
62.5 × 74.5
Lent by the National Coal Board

Henry Perlee Parker born 1795, exhibited between 1836 and 1853 a series of pictures of *'Pitmen at play'*. The painting submitted to the Royal Academy in 1836 was well received by the critics of the time. The reviewer in the Observer says:
 'Although the subject is not very refined yet the manner in which it is painted is so close to nature that we are compelled to like it'.
This series of pictures of *'Pitmen at play'*, five in all, was probably completed before 1840. They were eagerly sought after by the coal mining entrepreneurs of Newcastle following the artist's success at the Academy. Klingender, in *Art and the Industrial Revolution'* suggests that Parker's *'Pitmen'* may derive from a description given by M. Ross in Thomas Hair's *Sketches of the Coal Mines in Northumberland and Durham* published in 1839, although Parker had included references to miners in his earlier work. A watercolour of a seated pitman was painted in 1829 and he had exhibited his other mining picture *'Wives and bairns waiting the return of pitmen from work'* by 1837.

THE MINING COMMUNITY

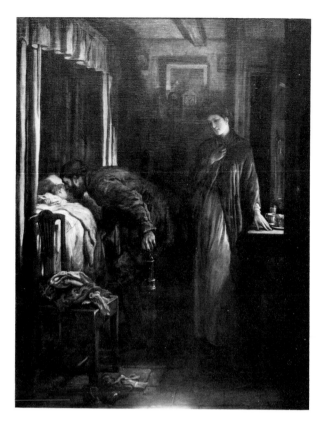

66. Alfred Dixon △
Get Up! 1884
Oil on canvas
183.8 × 141.9
Lent by the Laing Art
Gallery, Tyne and Wear
County Council Museums

Alfred Dixon born 1842,
submitted regularly to the
Royal Academy between
1870 and 1891. In 1882 and
1884 Dixon painted scenes
of pictures of pit life in the
North East. In his
Academy entry of 1884
Dixon turned his attention
to the 'Geordie' pitman
about to go on shift. This
time its title is less
forthcoming, but again it is
accompanied by four lines
of verse by the
Northumbrian pitman poet
Joseph Skipsey:
 'Get up' the caller calls,
'get up'
 and in the dead of night
 to win the bairns their
bite and sup

I rise, a weary night
continuing:
 My flannel dudden
downe'd thrice o'er
 my bairns are kissed
and then
 I with a whistle shut the
door
 I may not ope again'.

67. A. S. Hartwick
The Miner at Play
Daily Graphic, April 16
1892
Engraving
Lent by the Arts Council

68. A. S. Hartwick
The Miner at Play II
Daily Graphic, April 21
1892
Engraving
Lent by the Arts Council

**69. Rev. Francis
William Cobb**
*Miner out in the yard
feeding his pigeons*
1912-13
Photograph, modern print
18.5 × 21.7
Courtesy of the Public
Record Office, National
Coal Board Records

**70. Rev. Francis
William Cobb**
*Miner washing in front of
the fire* 1912-13
Photograph, modern print
20.8 × 18.4
Courtesy of the Public
Record Office, National
Coal Board Records

 'In a small corner-like
recess, full of floating
coal dust . . . glimmer
three or four candles,
stuck in clay which
adheres to wall and
roof; or there may be
only a couple of Davy
lamps . . . Close and
deliberate scrutiny will
discover one hewer
nearly naked, lying
upon his back,
elevating his small
sharp pickaxe a little
above his nose; another
picking into the
coalseam with might
and main; another is
squatting down and
using his pick like a
common labourer; a
fourth is cutting a small
channel in the seam,
and preparing to drive
in a wedge'.
From The Starbridge
Times, March, 1862

71. **Oliver Kilbourn**
Progging the mat 1930
Oil on board
64.2 × 44.1
Lent by the Trustees of the
Ashington Group

72. **George Blessed**
Whippets
Oil on board
38.5 × 51.8
Lent by the Trustees of the
Ashington Group

73. **J. Floyd** ◁
Pigeon Crees
Oil on board
63.5 × 43
Lent by the Trustees of the
Ashington Group

74. **J. F. Harrison** ◁
Jazz Band Parade c. 1950
Oil on board
74.2 × 59.5
Lent by the Trustees of the
Ashington Group

75. **Kurt Hutton**
*Miners carrying a heavy
banner* 1935
Photograph, modern print
28.4 × 21.4
Courtesy of Creative
Camera Collection and
Popperfoto

76. **Kurt Hutton**
Listening to the speeches
1935
Photograph, modern print
21.4 × 28.4
Courtesy of Creative
Camera Collection and
Popperfoto

Kurt Hutton (1893-1960)
took these pictures for a
Weekly Illustrated story
which appeared in the
August 10th issue titled
'Miner's day out':
 'Scores of thousands of
miners came by bus, train
or on foot to Durham
racecourse to hear
George Lansbury,
Herbert Morrison, Sir
Stafford Cripps and
Hannen Swaffer speak at
their annual gala'.

91

77. **Edith Tudor-Hart**
*Younger miners going
home. Rhondda Valley,
South Wales* c. 1936
Photograph, modern print
22 × 28
Lent by Wolfgang
Suschitzky

78. **Edith Tudor-Hart**
*Two miners. Rhondda
Valley, South Wales*
c. 1936
Photograph, modern print
22 × 28
Lent by Wolfgang
Suschitzky

Edith Tudor-Hart (1908-
1978) attended the
Bauhaus, Dessau, in 1931
and settled permanently
in Britain in 1933. She was
a member of the *Workers'
Camera Club* exhibiting
with the *Artists'
International Association*
from 1934. She visited the
Rhondda Valley to
photograph the mining
community in 1936, the
same year that Edwin
Smith made a similar trip
to the North East.

79. **Edwin Smith**
*Collier, seated by a Fire
Reading a Newspaper*
1936
Photograph, modern print
20.3 × 25.5
Lent by Olive Smith

80. **Edwin Smith**
*Miner's interior,
Newcastle* 1936
Photograph, vintage print
24.8 × 18
Lent by Olive Smith

81. **Edwin Smith**
*Mrs Denwood's House,
Scotswood on Tyne* 1936
Photograph, vintage print
16 × 24.8
Lent by Olive Smith

Edwin Smith's
photographs of the
Ashington and Tyneside
colliers were all taken
within the space of a
fortnight. They are all the
more remarkable,
because, despite being a
native of Camden town,
Smith seems to have
gained the confidence of
the normally suspicious

Geordie pitmen, enabling
him to make sympathetic
and eloquent pictures in a
time of unemployment
and deprivation. His
colliers bear comparison
with those pitmen in the
paintings of Parker,
Dixon, Ridley and
especially the Ashington
Group.

82. **Edwin Smith**
Coal tip/landscape 1936
Photograph, modern print
20.3 × 25.5
Lent by Olive Smith

83. **Edwin Smith**
Men playing quoits 1936
Photograph, modern print
25.5 × 20.3
Lent by Olive Smith

84. **Bill Brandt**
*Coal-Miner's Bath,
Chester-le-Street, Durham*
1937
Photograph, modern print
48.3 × 39.5
Lent by the Arts Council

85. Bill Brandt
Back Street in Jarrow 1937
Photograph, modern print
48.3 × 39.5
Lent by the Arts Council

86. Bill Brandt
*Coal Searchers near
Heworth* 1937
Photograph, vintage print
22.8 × 19.6
Lent by Bill Brandt

87. Bill Brandt
*Coal Searchers on the
side of a Tip* 1937
Photograph, vintage print
24.4 × 19.5
Lent by Bill Brandt

88. Bill Brandt
*Coal Searchers breaking
coal* 1937
Photograph, vintage print
22.7 × 19.7
Lent by Bill Brandt

89. Bill Brandt ▷
*Northumbrian Miner at his
evening meal* 1937
Photograph, vintage print
22.9 × 19.6
Lent by Bill Brandt

Brandt, born in 1905,
visited the North of
England in the early part
of 1937, but his trip was
not part of an assignment,
and very few, if any, of the
photographs he took were
published at the time. The
trip was made more in
response to the work of
the Mass Observation Unit
and the growing concern
for the plight of the poor
as expressed through the
literature of J. B. Priestley
and George Orwell.

90. John Bird
The Years of Victory 1947
Oil on canvas
110 × 122.7
Lent by the National Union
of Mineworkers (Durham
Area)

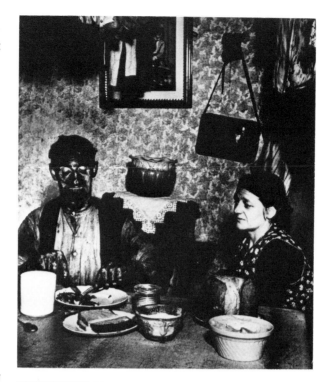

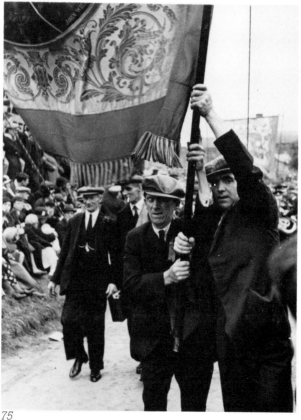

75

91. Josef Herman
*Evening Fall –
Ystradgynlais* 1948
Oil on canvas
76.2 × 122
Lent by Leicestershire
Museum, Art Galleries
and Records Service

Josef Herman arrived in
the Welsh mining village
of Ystradgynlais in the
summer of 1944. His
intention was to take a
short vacation but he
stayed and made the
village his home for
eleven years. In his
autobiographical book
'Related Twilights' he
recalls his reaction to
seeing a group of miners
and the image it
produced:
'This image of the
miners on the bridge
against that glowing sky
mystified me for years
with its mixture of sadness
and grandeur, and it
became the source of my
work for years to come'.
Herman's empathy for the
mining community was,
resolved in a series of
drawings and paintings
that began with reality,
but aimed at a wider
synthesis, both of form
and expression.

92. Eugene Smith
Welsh Miners c. 1950
Photograph, vintage print
25 × 30.2
Lent by the Victoria and
Albert Museum

95. **Bruce Davidson** ◁
Miner with a baby c. 1950
Photograph, modern print
35.5 × 28
Lent by the Arts Council

96. **Jane Bown**
After Aberfan 1967
Photograph, modern print
26 × 39.2
Lent by Jane Bown

93. **Robert Frank** ◁
Waiting to be Paid 1951
Photograph, modern print
24 × 34
Lent by the Lunn Gallery,
Washington D.C.

94. **Robert Frank**
Miners at Tea 1951
Photograph, modern print
34.5 × 23.5
Lent by the Lunn Gallery,
Washington D.C.

THE MINER

97. **R. & D. Havell** (after **George Walker**)
The Collier, 1814
Engraving
24.8 × 36.3
Lent by Ironbridge Gorge Museum Trust, Elton Coll.

George Walker's drawing of a collier at Middleton colliery first appeared as plate III in R & D Havell's *Costume of Yorkshire* published in 1814. It was re-issued in 1885 in the form of coloured lithographs by Edward Hailstone. Here the collier is linked visually with the very latest mining technology and steam locomotion at a colliery near Leeds. Charles Brandling, a figure much concerned with the development of railways in the North East, was the colliery's proprietor, and the locomotive has been identified as one of a number built by John Blenkinsop who was the colliery 'viewer'.

98. **William Miller**
Coal Heavers c. 1820
Engraving
23 × 31.5
Lent by Coal Factors' Society

99. & A-C **Reuben Townroe** ▽
Four studies for mosaic panel, 'Mining', c. 1850
Charcoal
37 × 22 each
Lent by the Victoria and Albert Museum

100. **Reuben Townroe** ▽
Mining (study for mosaic panel for the south wall of the quadrangle of the Victoria & Albert Museum) c. 1850
Watercolour and ink
12 × 26.5
Lent by the Victoria and Albert Museum

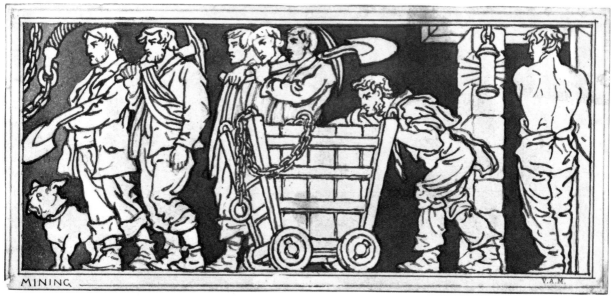

MINING
V.A.M.

101. **Arthur J. Munby** ▷
Pit brow woman
Shevington 1864
Photograph, modern print
28.5 × 17.5
Courtesy of the Master
and Fellows of Trinity
College, Cambridge

102. **Arthur J. Munby**
Miner and pit brow
woman, Wigan
Photograph, modern print
16 × 10
Courtesy of the Master
and Fellows of Trinity
College, Cambridge

103. **M. W. Ridley**
Heads of the People VI,
The Miner
The Graphic, April 15
1876
Engraving
Lent by Leicester
Polytechnic

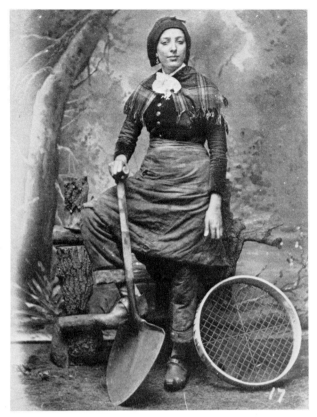

104. **J. Floyd**
The Miner c. 1930
Oil on canvas
39.3 × 29.4
Lent by the Trustees of the
Ashington Group

105. **Albertus Antonius**
Houthuesen ▽
The Collier 1933
Oil on canvas
67.9 × 49.5
Lent by Sheffield City Art
Galleries

Albert Houthuesen was,
like Josef Herman, an
émigré. After living in this
country for many years he
made a short holiday in
North Wales. This chance
visit to Llanasa placed him
very near the Point of Aiv
colliery and he became
absorbed by the working
life of the colliers he met
there.

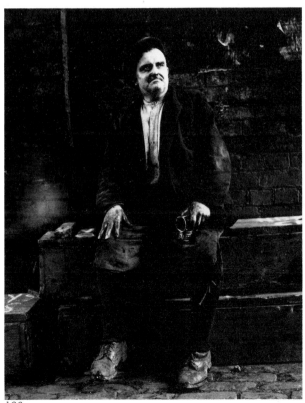

106

106. & A, B **Edwin Smith**
Northumberland,
Ashington collier (three
versions) 1936
Photographs, vintage
prints
25.3 × 17.9, 25 × 17.1,
24.2 × 15.8
Lent by Olive Smith

107. **Edwin Smith**
Shiny Boots 1936
Photograph, modern print
35.5 × 24.2
Lent by Olive Smith

108. **Andrew Freeth** △
Griffith Thomas 1946
Charcoal and crayon
42.4 × 31.5
Lent by the National Coal
Board

109. **Andrew Freeth**
William Bumble, Deputy
c. 1947
Pencil
41.6 × 30.6
Lent by the National Coal
Board

110. **Andrew Freeth** △
Herbert Humphrey 1948
Pen and wash
36.5 × 28
Lent by the National Coal
Board

Andrew Freeth was
commissioned to make a
series of portraits of
miners and colliery
officials in the first year
after Nationalisation at
selected collieries
throughout Britain.

111. **Josef Herman** ◁
The Welsh Miner 1948
Oil on board
78 × 58
Lent by the Arts Council

112. **Oliver Kilbourn** ◁
Pithead baths
Oil on wood
67 × 52
Lent by the Trustees of the
Ashington Group

113. **Tom McGuinness** △
Pithead Baths
Oil on board
45 × 48.3
Private Collection

Tom McGuinness could
be described as one of the
second generation of
North Eastern pitmen
painters. At eighteen he
had became a 'Bevin Boy'
and remained a working
collier in his native
Durham. Art classes at
Darlington, Doncaster and
the Spennymoor
Settlement set
McGuinness on his way.
He has pursued his art
practice with a
professional tenacity and
developed a strong
personal view of the
industry.

114. **Tom McGuinness**
*Miner washing in front of
fire* 1948
Chalk and crayon
35.5 × 50.8
Private Collection

115. **Tom McGuinness**
Miner undressing 1947/8
Chalk and pencil
49 × 35,5
Private Collection

116

116. **Jack Crabtree**
The Dirty Clothes Lockers
1974
Pen and ink
28 × 38.1
Lent by the National Coal
Board

117. **Jack Crabtree**
*Mr Davies, the vet, with
owl* 1974
Watercolour
30.5 × 40.6
Lent by the National Coal
Board

118. **Jack Crabtree** ▷
*Going down the ramp,
afternoon shift, Britannia*
1975
Oil on canvas
91.5 × 112.7
Lent by the National Coal
Board

Jack Crabtree's
experience as an
artist/miner is unique. He
approached and was
accepted by the National
Coal Board, for a year's
commission (1974/5) in
which he would attempt to
depict working life in the
South Wales coalfield.
After an initial period of
safety training Crabtree
was allowed access to
surface installations and
more important for him,
the underground coal
faces.

119. **Michael Martin** ▷
*Retired Miner in his
Garden* 1980
Oil on paper
47 × 33
Lent by Michael Martin

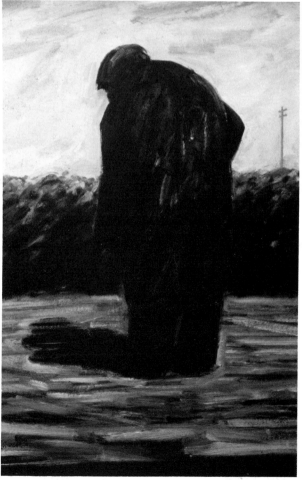

4

THE LANDSCAPE
UNDERGROUND

120. **Thomas H. Hair** ▷
Crane for Loading the Rollies c. 1842
Watercolour
30.5 × 23 (approx.)
Lent by the Department of Mining and Engineering, University of Newcastle upon Tyne

121. **Thomas H. Hair** ▽
The Bottom of the Shaft, Walbottle Colliery c. 1842
Watercolour
30.5 × 23 (approx.)
Lent by the Department of Mining and Engineering, University of Newcastle upon Tyne

In this underground scene, corves, or wicker baskets full of coal are being loaded onto 'trams'. These trams were dragged by horses, or in some instances by men and boys, to the shaft bottom. At the shaft bottom the corves were attached to the winding rope and drawn to the surface.

122. **M. W. Ridley**
Pitmen Hewing Coal
The Graphic, January 28 1871
Engraving
Lent by Leicester Polytechnic

123. **A. S. Hartwick**
The Miner at Work
Daily Graphic, April 7 1892
Engravings
Lent by the Arts Council

124. **A. S. Hartwick**
The Miner at Work II
Daily Graphic, April 8 1892
Engravings
Lent by the Arts Council

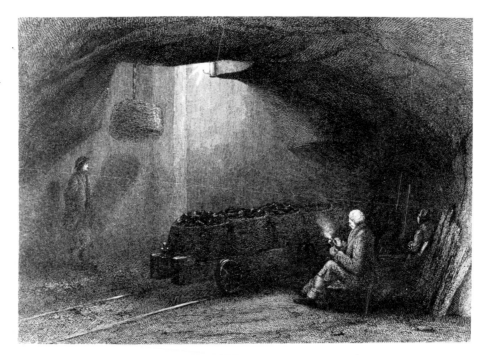

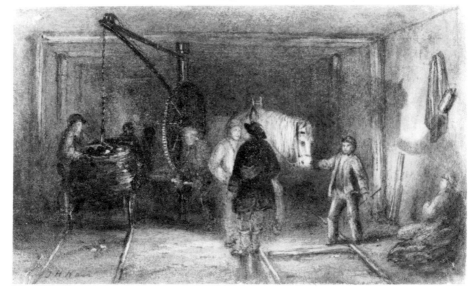

125. **Rev. Francis** ▷
William Cobb
Hand Holing, Brinsley
Colliery, Nottinghamshire
1912/13
Photograph, modern print
17.5 × 23.2
Courtesy of the Public
Record Office, National
Coal Board Records

126. **Rev. Francis William**
Cobb
Break time 1912/13
Photograph, modern print
18.5 × 21.8
Courtesy of the Public
Record Office, National
Coal Board Records

127. **Sir Frank Brangwyn** ▽
The Miners 1917
Coloured chalk and
watercolour
59.5 × 71
Lent by Sheffield City Art
Galleries

In 1905 Frank Brangwyn
embarked on a series of
'industrial' paintings for
the English room at the
Venice exhibition. The
four panels exhibited,
Weavers at Work,
Workers in Steel,
Blacksmiths, and *Potters,*
relate to a series of
etchings and engravings
which explored other
aspects of industrial and
commercial life. Walter
Shaw-Sparrow in a
biography of the artist's
work up to 1914, lists well
over 50 etchings, at least
25 lithographs, and
numerous sketches and
drawings all related to
themes of work. Amongst
the British subjects listed
are *Miners pushing trucks*
of coal.

128. **Gilbert Daykin**
Sketch for Markham's
Ponies c. 1928
Ink
31.8 × 38.1
Lent by the Science
Museum

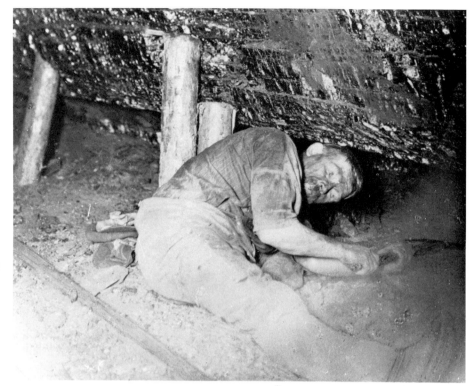

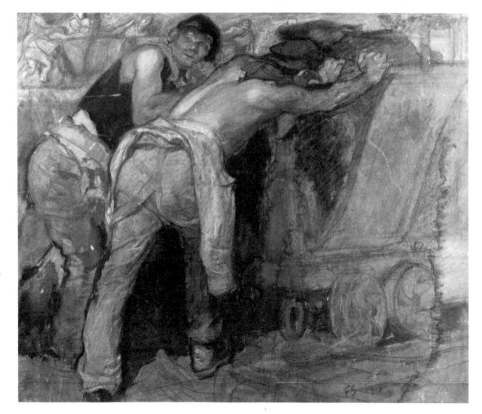

129. **Gilbert Daykin**
*Wedging down Coal
which has been Undercut*
c. 1930
Oil on canvas
61 × 50.8
Lent by the Science
Museum

130. **Gilbert Daykin**
*Miner filling tub in
restricted area* c. 1930
Oil on canvas
64.8 × 76.2
Lent by the Science
Museum

131. **Gilbert Daykin** ▷
*Symbolic – The Miner with
Chains* 1937–8
Oil on canvas
76.2 × 63.5
Lent by the Science
Museum

132. **Bill Brandt**
*Miners Returning to
Daylight* 1933
Photograph, modern print
48.3 × 39.5
Lent by the Arts Council

133. **Vincent Evans**
*Repairing a Main
Roadway* c. 1930
Oil on canvas
100.5 × 125.5
Lent by the National Coal
Board

134. **Vincent Evans** ▷
After the Blast
Oil on canvas
50.6 × 72
Lent by the National Coal
Board

Vincent Evans was a South
Wales collier who left the
pits at the age of 23 with a
scholarship to the Royal
College of Art. His
earliest drawings relate
very directly to his own
experience of coal
mining. The later, larger
works are retrospective
but give a strong
impression of working
conditions in the 1920s
and 1930s.

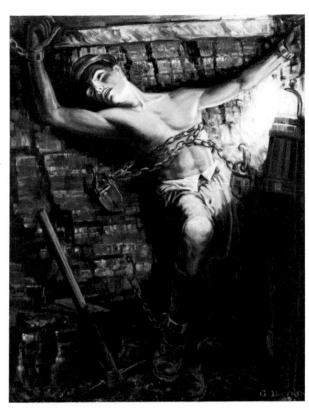

135. & A-L **Tisa von der
Schulenburg**
Diary 1936-38 – 13 pages
(facsimile prints of Diary
pages)
Screen prints, edition 6/20
36.8 × 30.5 each
Private Collection

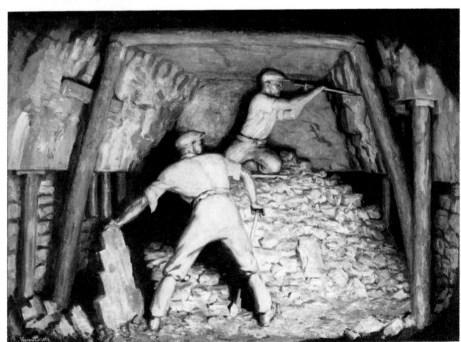

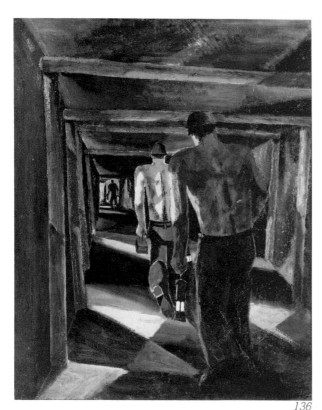

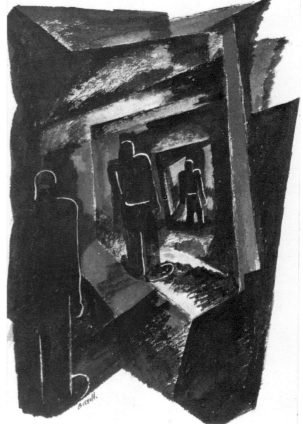

136

138

136. **George Bissell**
Going on Shift c. 1930
Oil on canvas
54.5 × 44.5
Lent by the National Coal
Board

137. **George Bissell**
Working the Seam c. 1930
Oil on canvas
35 × 30
Lent by the National Coal
Board

138. **George Bissell**
Design of Underground
1946
Gouache and watercolour
39 × 27.5
Lent by the National Coal
Board

139. **George Bissell** ◁
Timbering
Woodcut
8.4 × 11.7
Lent by the Victoria and
Albert Museum

140. **W. Heath Robinson** ▷
The Pit (section) c. 1930s
Lithograph
33 × 22
Lent by the National Coal
Board

141. **W. Heath Robinson**
Pit Head c. 1930s
Lithograph
33 × 22
Lent by the National Coal
Board

142. **W. Heath Robinson**
*Screening and Picking
coal* c. 1930s
Lithograph
33 × 22
Lent by the National Coal
Board

143. **W. Heath Robinson**
*A Busy Day in the
Washery* c. 1930s
Lithograph
33 × 22
Lent by the National Coal
Board

144. **Charles William
Brown**
Coalcutter 1938
Watercolour and ink
24.5 × 34.5
Lent by the City Museum
and Art Gallery, Stoke-
on-Trent

145. **Charles William
Brown**
Miners at the Coal Face
1943
Watercolour and ink
34.6 × 24.5
Lent by the City Museum
and Art Gallery, Stoke-
on-Trent

Almost entirely self-
taught, Brown painted and
drew the things that he
observed around him
compulsively. He left
behind an
autobiographical record
of his pit life, home life,
and the immediate
surroundings and
industry of his native
potteries. The intensity of

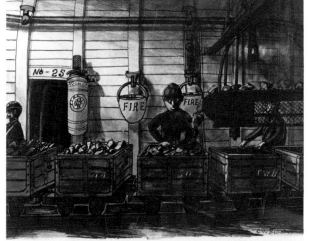

146

the artist's vision
overcomes the naivety of
style particularly in his
colliery paintings. He
used his intimate
knowledge of pit work to
great effect in a series of
underground scenes.

'I have had a busy time
in the sphere of mining,
but that has not deterred
me from practising what
has been for the past 40
years or more a hobby by
way of draughtsmanship,
which has in later years
become a profession in
the sphere of art, picture
painting in black and
white and watercolours'.

146. **Charles William
Brown**
*Loading Trucks from a
Conveyor Belt*
Watercolour and ink
22 × 28.3
Lent by the City Museum
and Art Gallery. Stoke-on-
Trent

147. **Charles William
Brown**
*The Parkhouse Colliery,
Chesterton* 1944
Watercolour and ink
24.6 × 34.7
Lent by the City Museum
and Art Gallery, Stoke-on-
Trent

148. **Oliver Kilbourn**
Coal face drawers
Watercolour
55 × 75.2
Lent by the Trustees of the
Ashington Group

149. **G. Brown**
Coal tubs off the way
Oil on board
40 × 55
Lent by the Trustees of the
Ashington Group

150. **L. Brownrigg** ▷
The Miners (underground)
Oil on wood
45.1 × 34.7
Lent by the Trustees of the
Ashington Group

151. **Henry Moore**
*Miners at work on the coal
face* 1942
Pen and Indian ink and
grey wash, with chalk and
crayon
33.3 × 55.3
Lent by the Whitworth Art
Gallery, University of
Manchester

152. & A **Henry Moore** ▽
*Studies in Mining-
two pages from a
sketchbook*
Pencil
24.1 × 17.8 each
Lent by Sheffield City Art
Galleries

153. **Henry Moore**
Miners at work 1942/3
Pen and Indian ink and
grey wash, with chalk and
crayon
56.6 × 43
Lent by the Whitworth Art
Gallery, University of
Manchester

It was as a war artist that
Henry Moore returned to
his native town of
Castleford. His task was to
visit Wheldale colliery
and sketch the miners at
work on the coal face.
Thirty years later he
recalled the experience of
working in the pit:
 'To record in drawing
what I felt and saw was a
new and very difficult
struggle. First there was
the difficulty of seeing
forms emerging out of the
deep darkness, then the
problem of conveying the
claustrophobic effect of
countless wooden pit
props, 2 or 3 feet apart,
receding into blackness,
and expressing the gritty,
grubby smears of black
coal dust on the miners'

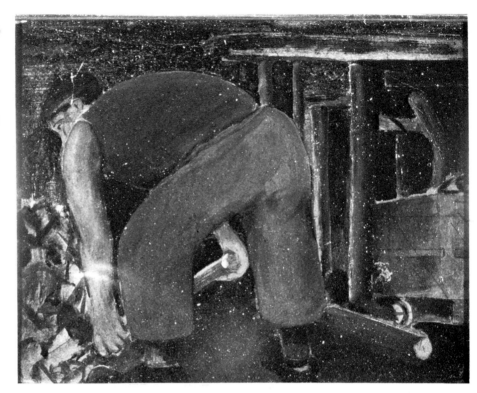

bodies and faces at the
same time as the anatomy
underneath'.
Conditions were so
cramped that he had to
make, 'the larger
coalmine drawings back
home in Hertfordshire,
from sketches and
diagrams and written
notes done in the mine.'

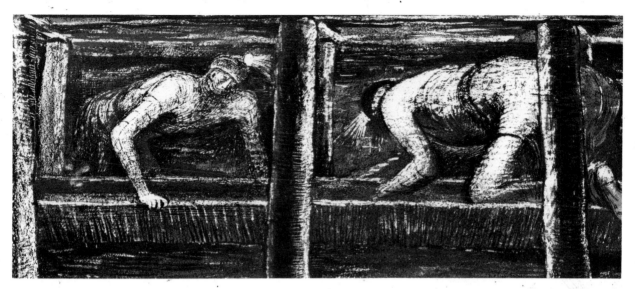

154. **Henry Moore** △
*Men clearing coal face
and climbing over belt,*
1942
Crayon and ink
27.5 × 64.7
Lent by City of
Manchester Art Galleries

155. **Tom McGuinness** ▽
Mother Gate Stone Men
Oil on board
121.3 × 123.3
Private Collection

156. **Tom McGuinness**
Canch-Men 1958
Oil on board
48.2 × 99.7
Private Collection

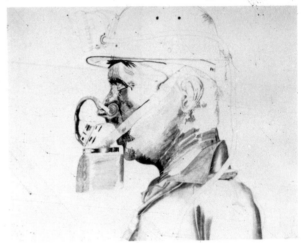

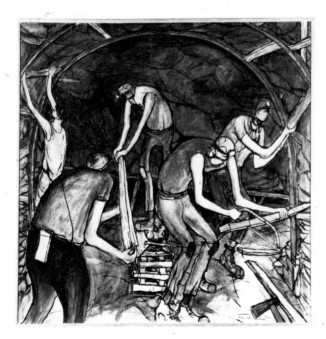

157. **Robert Frank**
Waiting to go up 1951
Photograph, modern print
25.5 × 34
Lent by the Lunn Gallery,
Washington D.C.

158. **Robert Frank**
Miner Underground, 1951
Photograph, modern print
34.5 × 23.5
Lent by the Lunn Gallery,
Washington D.C.

159. **Keith Vaughan** ▷
Miners fixing supports
1952
Pastel, black Indian ink
and wash
35.5 × 26.2
Lent by Bolton Museum
and Art Gallery

160. **Jack Crabtree**
*Five Pitmen prior to
alighting* 1975
Watercolour
38.1 × 38.1
Lent by the National Coal
Board

161. **Jack Crabtree** ◁
Using a Respirator 1975
Coloured pencil
30.5 × 40.6
Lent by the National Coal
Board

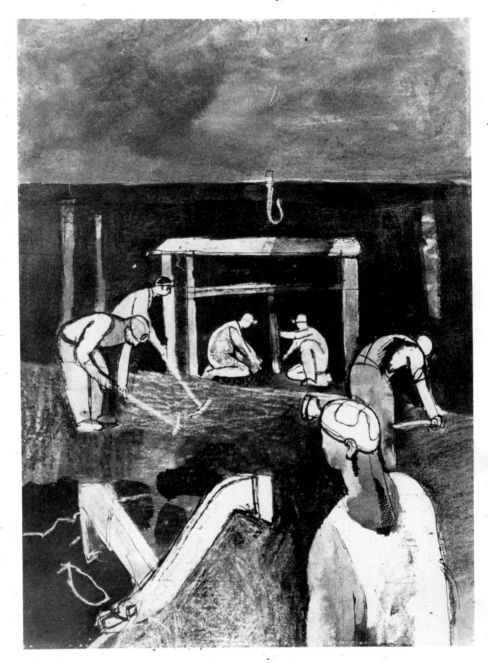

CHRONOLOGY

Industrial, Economic and Social Events		Cultural	
1709	First smelting of iron with coke	1697	William Hogarth born (d. 1764)
	at Coalbrookdale by Abraham Darby	1727	Thomas Gainsborough born (d. 1788)
1712	First Newcomen engine for pumping	1735	Daniel Defoe - 'A Tour Through the
1720	South Sea Bubble		Whole Island of Great Britain'
1725	Causey Arch built to carry coal waggons,		Hogarth - 'Rake's Progress' published
	South West of Newcastle	1756	Edmond Burke - 'Inquiry into the Origin
1761	Bridgwater Canal opened		of our ideas on the Sublime and Beautiful'
1766	T. R. Malthus born (d. 1834)	1758	First known views of Coalbrookdale
1773	First cast-iron bridge built at Coalbrookdale		by Thomas Smith and George Perry
1775	First commercial employment of	1768	Foundation of the Royal Academy
	Watt's improved steam engine		Rev. William Gilpin's first tour of Britain
1780	Steam Engine adapted for winding	1771	Joseph Wright's painting 'Blacksmith's Shop'
	coal to the surface	1773	Wedgwood sets up the new pottery at Etruria, Stoke
1781	George Stephenson born (d. 1848)	1775	J. M. W. Turner born (d. 1851)
1787	Curr's Iron Plateway, first use of	1776	John Constable born (d. 1837)
	iron rails, near Sheffield	1791	Ordnance Survey established in Britain
1799	Combination Laws	1792	William Gilpin - 'Three Essays on Landscape Painting'
1801	First iron trolley tracks,	1802	J. S. Cotman and P. Sandby Munn
	Croydon - Wandsworth		visit Coalbrookdale
1804	Penydarren tramway, first-steam	1812	Charles Dickens born (d. 1871)
	locomotive hauled railway		J. M. W. Turner's paintings 'Snow Storm'
1814	First Stephenson steam locomotive constructed -		and 'Hannibal and his Army crossing the Alps'
	at Killingworth Colliery near Newcastle	1819	J. A. Senefelder's -
1815	Humphrey Davy and George Stephenson		'A Complete Course of Lithography'
	invent miners' safety lamps	1820	Théodore Géricault begins visit to England
1819	'Peterloo' Massacre	1821	John Constable's painting 'The Haywain'
1824	Combination Laws repealed	1829	Thomas Carlyle - 'Signs of the Time'
1825	Stockton to Darlington Railway opened	1836	Henry Perlee Parker's painting
1830	Liverpool and Manchester Railway		'Pitmen at Play' exhibited at the Royal Academy
1831	Truck Act; outlawed payment of miners'	1837	Thomas H. Hair begins his watercolour series
	wages in form of credit notes or goods		of collieries in Northumberland and Durham
1832	Reform Act; Parliamentary franchise	1842	Thomas Hood - 'Song of the Shirt'
	extended and voting system reformed	1843	John Ruskin - 'Modern Painters' Vol. I
1833	First Factory Act provides a system		Charles Dickens - 'Christmas Carol'
	for factory inspection	1844	Turner's painting 'Rain, Steam and Speed'
1842	Children's Employment Commission - women	1847	James Sharple's painting 'The Forge'
	and children prohibited from working in mines	1848	Mrs. E. Gaskell - 'Mary Barton'
1845	Coal first delivered to London by railway		Founding of the Pre-Raphaelite Brotherhood
1847	Second Factory Act restricts the working day to 10	1849	Coal Exchange,
	hours for women and children between 13 and 18		London by Bunning completed
1848	John Stuart Mill - Principles of Political Economy	1851	Great Exhibition, Paxton's 'Crystal Palace'
1850	Coal Mines Inspection Act		Henry Mayhew - 'London Labour, London Poor'
	School of Mines established in London	1852	Ford Madox-Brown's painting 'Work'
	Opening of Stephenson's cast-iron	1853	John Ruskin - 'Stones of Venice'
	railway bridge at Newcastle	1854	Charles Dickens - 'Hard Times'

Industrial, Economic and Social Events		Cultural	
1854	Working Men's College established in London	1859	Charles Darwin's 'On the origin of the Species by Means of Natural Selection'
1856	Keir Hardie born (d. 1915)	1864	First photographs of pit brow women by A. H. Munby
1857	Science Museum opens in London	1865	Lewis Carroll - 'Alice's Adventures in Wonderland'
1859	Samuel Smiles - 'Self-Help'	1867	Karl Marx - 'Das Kapital'
1862	Hartley Colliery disaster	1874	Eyre Crow's painting 'Dinner hour - Wigan'
1870	Forster's Education Act		Thomas Hardy - 'Far from the Madding Crowd'
1871	Bank Holidays introduced in England and Wales	1877	John Thompson - 'Street Life in London' - photographs
1880	British railway mileage reaches 17,900	1884	Art Workers' Guild established in Britain
1882	Electric lighting introduced	1886	Émile Zola - 'Germinal'
1887	Coal Mines Regulation Act	1893	Hubert von Herkomer's painting 'On Strike'
1889	First May Day celebration	1898	H. G. Wells - 'War of the Worlds'
	Formation of Miners' Federation of Great Britain		Henry Moore born
1890	First electrical power station in England at Deptford		
1903	Wright Brothers flight across the Channel	1913	New York Armory Show
1908	Eight Hours Act	1924	British Empire Exhibition, Wembley
1912	First National Strike	1928	D. H. Lawrence - 'Lady Chatterley's Lover'
1913	Record output of coal. Senghenydd disaster	1935	Ashington Group of artist-miners formed
1914-18	First World War		John Grierson directs 'Coal Face'
1919	Sankey Commission on coal industry	1936	Bill Brandt - 'The English at Home'
1920	Coal production in Britain 229 million tonnes	1937	George Orwell - 'Road to Wigan Pier'
1923	Grouping of railways	1940-45	Henry Moore, Graham Sutherland, Stanley Spencer, John Piper amongst others commissioned as official War Artists
	Registered Trade Union membership in Britain 4,369,000	1941	Film version of Richard Llewellyn's novel 'How Green was my Valley'
1925-6	Samuel Commission on coal industry	1944	Josef Herman visits and settles in Ystradgynlais
1926	General Strike		
1928	First complete talking picture	1946	"Britain Can Make It" exhibition, Victoria and Albert Museum
1939-45	Second World War		
1942	Nuclear fission achieved	1947	Humphrey Jennings directs 'The Cumberland Story'
1945	Formation of National Union of Mine Workers (NUM)	1951	Festival of Britain
1946	Coal Industry Nationalisation Act	1954	Dylan Thomas - 'Under Milk Wood'
1947	National Coal Board comes into operation	1956	American photographer Robert Frank visits Welsh coalfields to be followed by Eugene Smith and Bruce Davidson
1948	Nationalisation of the Railways		
1955	National Day-Wage Agreement		
1956	'Dido', first nuclear fuelled reactor, opened at Harwell	1965	L. S. Lowry's painting of the Welsh coal town of Burgoed
1966	National Power Loading Agreement (consolidated piecework agreements into a national structure)	1968	Alan Plater . 'Close the Coalhouse Door'
		1973	Bernd and Hilla Becher begin photographic survey of English and Welsh collieries
1967	First Arab-Israeli war - beginning of oil crisis	1976	Barry Hines - 'Kes'
1972	National Miners' Strike	1979	'Artist in Industry' scheme initiated in Britain
1973	Britain joins E.E.C.		
1974	Miners' Strike; Three-day week; 'Plan for Coal'; height of oil crisis		
1978	Incentive Scheme introduced		
1980	Kellingley Colliery first mine to produce 2 million tonnes a year		

ARTISTS INDEX

Becher, Bernd + Hilla **47, 48+A**
Bell Scott, William **55**
Bird, John **90**
Bissell, George **136-139**
Blessed, George **72**
Bown, Jane **96**
Brandt, Bill **84-89, 132**
Brangwyn, Frank **127**
British School **29, 32, 49, 50**
Brown, C W **46, 144-147**
Brown, G **149**
Brownrigg, L **150**

Carmichael, J W **35, 39**
Clausen, George **41**
Clough, Prunella **15**
Cobb, Rev. F W **69, 70, 125, 126**
Collingwood-Smith, William **8**
Constable, John **5**
Cotman, J S **27**
Crabtree, Jack **116-118, 160, 161**

Davidson, Bruce **95**
Daykin, Gilbert **128-131**
Dineley, Thomas **21**
Dixon, Alfred **66**
Dodd, Robert **7**

Evans, Vincent **133, 134**

Fessard, Etienne **23, 24**
Floyd, J **73, 104**
Frank, Robert **93, 94, 157, 158**
Freeth, Andrew **108-110**

Géricault, T **33**

Hair, Thomas H **34, 57, 120, 121**
Harrison, J F **74**
Hartover, Peter **1**
Hartwick, A S **67, 68, 123, 124**
Hassell, John **25**
Havell, R & D **97**
Heath Robinson, W. **140-143**
Herman, Josef **91, 111**
Holl, Francis **59**
Houthuesen, A A **105**
Hutton, Kurt **75, 76**

Ibbotson, Julius Caesar **26**

Keen, Hannah **62**
Kilbourn, Oliver **71, 112, 148**

Laporte, John **30**
Latham, John **18**
Leech, John **53**
Leonard, J H **56**
Lowry, L S **12, 13, 40**

Major, Theodore **31**
Martin, Michael **19, 20, 119**
McGuinness, Tom **113-115, 155, 156**
Miller, William **98**
Mitchell, William **9**
Moore, Henry **151-154**
Munby, A J **101, 102**
Munn, P S **28**

Onwin, Glen **16, 17**
Overend, W H **61**

Pankhurst, Sylvia **63**
Perlee Parker, Henry **64, 65**
Piper, John **14**

Richardson, T M **38**
Ridley, M W **103, 122**
Roberts, David **54**
Robson, J **58**
Roffe, R C **51**

Sandby, Paul **22**
Schulenburg, Tisa von der **135**
Smith, Edwin **79-83, 106, 107**
Smith, Eugene **92**
Sutherland, Graham **44, 45**

Townroe, Reuben **99, 100**
Tudor-Hart, Edith **77, 78**
Turner, Charles **6**

Vaughan, Keith **159**
Vivares, François **2, 3**

Wadsworth, Edward **11**
Walker, Francis **60**
Westwood, J **29A**
Wheldon, W **36, 37**
Wilkinson, N **42**
Williams, Penry **52**
Williams, William **4**
Wilson, H **43**
Wyllie, William **10**

LIST OF LENDERS

Aberdeen Art Gallery **45**
Arts Council of Great
Britain **18, 67, 68, 84, 85,
95, 111, 123, 124, 132**
Trustees of the Ashington
Group **43, 71-74, 104, 112,
148-150**
Visitors of the Ashmolean
Museum, Oxford **44**

Bolton Museum and Art
Gallery **159**
Jane Bown **96**
Bill Brandt **86-89**

Master and Fellows of
Trinity College,
Cambridge **101, 102**
Clive House Museum,
Shrewsbury **4**
Coal Factors Society **7, 10,
29, 29A, 33, 49, 50, 54, 98**
Creative Camera
Collection **75, 76**

William R Hill **62**

Ironbridge Gorge
Museum **2, 3, 8, 23, 24, 25,
28, 30, 35, 59, 97**

Lord Lambton **1**
Leeds City Art Galleries
27, 47
Leicester Polytechnic **53,
60, 61, 103, 122**
Leicestershire Museum,
Art Galleries and
Records Service **91**
Lunn Gallery, Washington
DC **93, 94, 157, 158**

City of Manchester Art
Galleries **11, 154**
Michael Martin **19, 20, 119**
Merthyr Tydfil Borough
Council **52**

National Coal Board **9,
65, 108-110, 116-118, 133,
134, 136-138, 140-143, 160,
161**

National Library of
Wales, Cardiff **21**
National Museum of
Wales, Cardiff **14, 22, 51**
National Portrait Gallery
63
National Railway
Museum, York **41, 42**
National Trust **55**
National Union of
Mineworkers **90**
Department of Mining
Engineering, University
of Newcastle **34, 120, 121**

Glen Onwin **16, 17**

Dr Peter Phillips **12**
Private Collections **48 &
A, 113-115, 135, 155, 156**
Public Record Office **69,
70, 125, 126**

Sir William Rees-Mogg **26**

City of Salford Art Gallery
31, 40
Science Museum **36, 37,
128-131**
Sheffield Art Galleries **15,
105, 127, 152**
Olive Smith **79-83, 106,
107**
City Museum and Art
Gallery, Stoke-on-Trent
46, 144-147
Wolfgang Suschitzky **75,
76**

Tyne and Wear County
Council Museums **13, 38,
39, 56, 57, 58, 64, 66**

Victoria and Albert
Museum **5, 6, 92, 99, 100,
139**

Walker Art Gallery,
Liverpool **32**
Whitworth Art Gallery,
University of Manchester
151, 153

SELECT BIBLIOGRAPHY

General and Technology

Nef, John U.,
*The Rise of the British
Coal Industry* (Routledge,
1932)

Mining Association of
Great Britain, *Historical
Review of Coal Mining*
(MAGB, 1924)

Galloway, Robert L.,
*A History of Coal Mining
in Great Britain* (1882;
reprinted David and
Charles, 1969)

Berkovitch, Israel,
Coal on the Switchback
(Allen and Unwin, 1977)
post Nationalisation

Buxton, Neil K.,
*The Economic
Development of the
British Coal Industry*
(Batsford, 1978)

Flinn, Michael W.,
*History of the British Coal
Industry, Volume II 1700-
1830* Oxford University
Press, (forthcoming)

Kirby, M. W.,
*The British Coal Industry,
1870-1946* (Macmillan,
1977)

National Coal Board,
*Coal: Technology for
Britain's Future*
(Macmillan, 1976)

Labour

Arnot, R. Page,
*The Miners: A History of
the Miners' Federation of
Great Britain 1889-1910*
(Allen & Unwin, 1949)

Arnot, R. Page,
*The Miners: Years of
Struggle: A History of the
Miners' Federation of
Great Britain* (Allen &
Unwin, 1953)

Arnot, R. Page,
*The Miners: in a Crisis
and War: A History of the
Miners' Federation of
Great Britain* (Allen &
Unwin, 1961)

Arnot, R. Page,
*The Miners: One Union,
One Industry* (Allen &
Unwin, 1979)

John, Angela,
*By the Sweat of their
Brow: Women Workers at
Victorian Coal Mines*
(Croom Helm, 1980)

Cultural

Heinrich Winkelmann –
Der Bergbau in der Kunst
Published 1958

F. D. Klingender
*Art and the Industrial
Revolution* Edited and
revised by Arthur Elton
(by Evelyn, Allan and
MacKay, 1968)